THE
WATERCOLOR
COURSE
YOU'VE ALWAYS WANTED

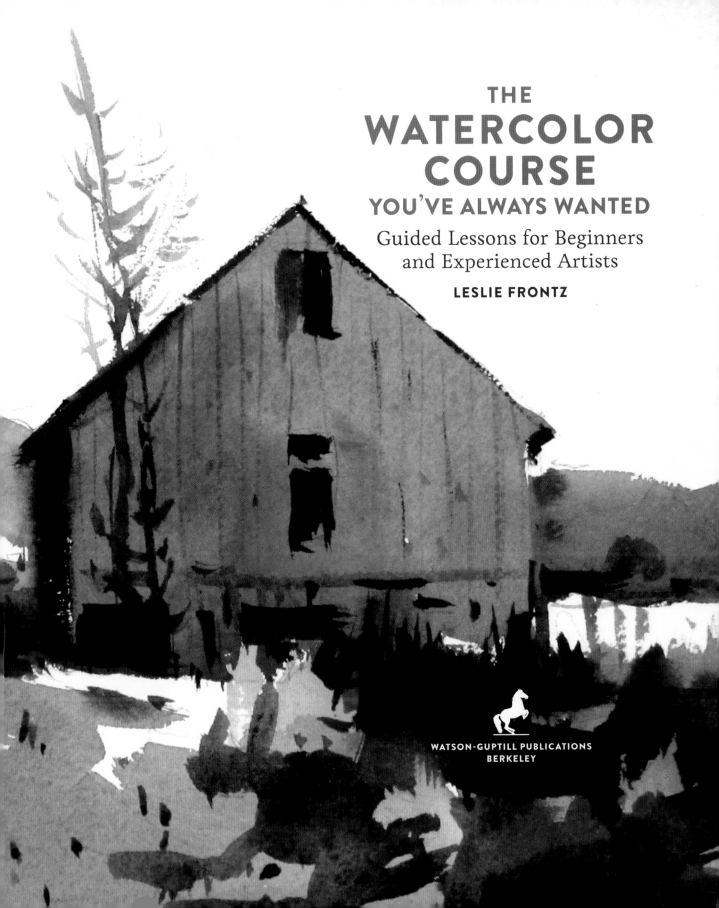

THE
WATERCOLOR
COURSE
YOU'VE ALWAYS WANTED

Guided Lessons for Beginners
and Experienced Artists

LESLIE FRONTZ

WATSON-GUPTILL PUBLICATIONS
BERKELEY

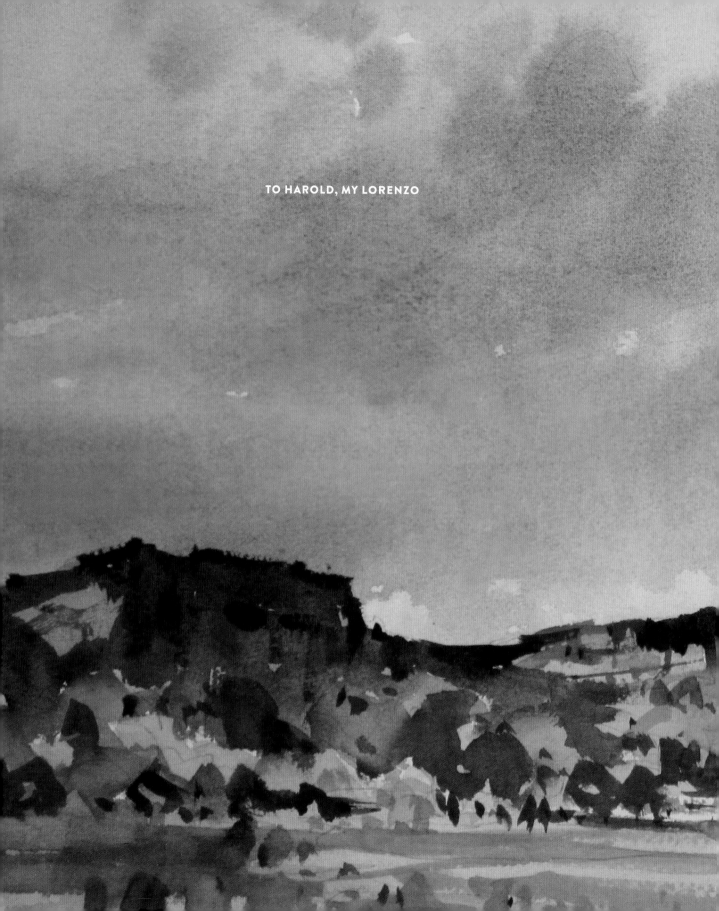

TO HAROLD, MY LORENZO

Contents

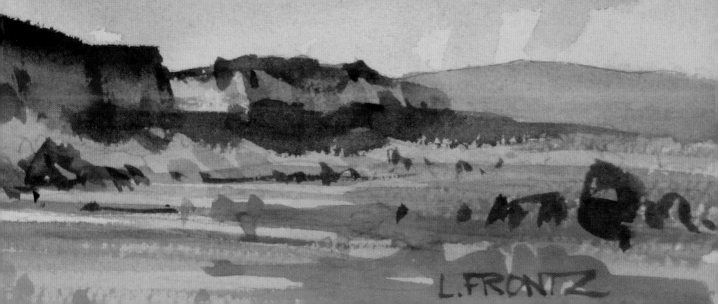

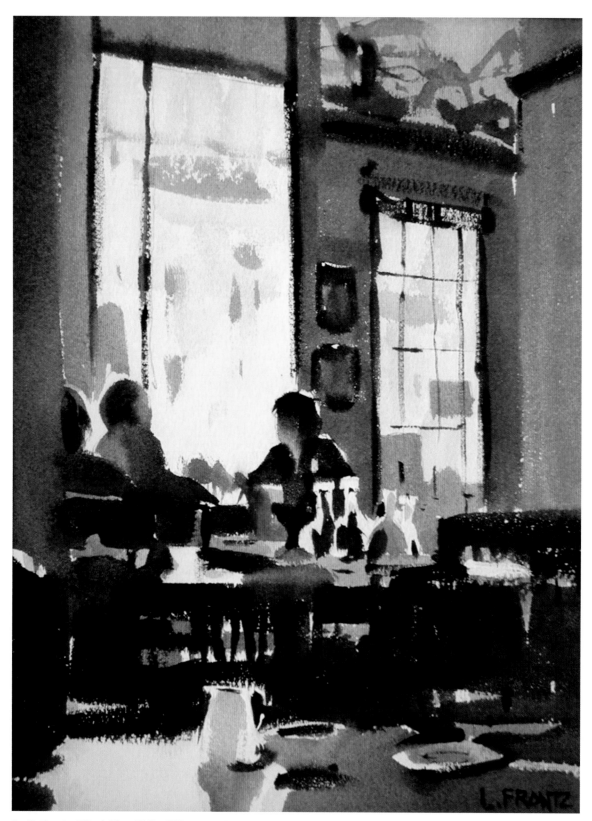

Leslie Frontz, *Tête-à-Tête*, 11½" x 8½", watercolor on paper.

Introduction

This course is the result of years of teaching art: in colleges, public school, and now in workshops. My students ranged in age from five to seventy-five, and many had a sound introduction to art. Over the years, I saw that they had learned what to do, but not why or when. Often, they had simply acquired a set of rules, and they struggled to put theory into practice. This book goes beyond the rules.

Watercolor promises so much: glowing color and bold brushwork, strong shapes, and expressive lines. Because the medium is transparent, the progress of every stroke of paint is detectable, making the artist's journey visible. Looking at a fine watercolor is an inspiring experience, but painting one is even better.

Watercolor's transparency and fluidity have earned it an undeserved reputation as a fickle medium. All forms of painting take practice. What makes watercolor different is that working with sheer layers of color encourages innovation and vision: the ability to develop a personal notion about a subject and express it. Watercolor prompts us to become artists as well as painters.

The Watercolor Course You've Always Wanted is a workshop in a book. Like my workshops, this book guides everyone—absolute beginners as well as seasoned artists—beyond the basics. The course offers a solid foundation in the mechanics, but it also helps you make the most of your subjects and ideas. If your hopes include turning out accomplished watercolors on a consistent basis, this book will help you get there. It teaches the skills needed to follow through on your own creative impulses: how to make the choices that will work best for *you*.

The key to the course is that it encourages you to think like an artist. A series of guided lessons covers a progression of topics: from seeing the potential in a subject to developing a personal style. Putting the workshop in book form allows you to set your own pace, go back to review, and even repeat a section as necessary. The sequence is carefully orchestrated, though the order in which information is presented may be surprising. It is an exhilarating way to learn, but forewarned is forearmed: skipping chapters is a risky business.

The point is to expand your horizons. The chapters include step-by-step demonstrations as well as the work of students and other fellow artists. If you are a landscape painter, do not hesitate to try a still life or portrait. The lessons are pertinent to all subject matter; they simply provide a way to learn by doing. Personal tips also speed your progress. The demonstrations have been field-tested, and they are all within reach. Most of what you will learn is common sense. My students would agree. "So this is all there is to it?" "The explanation makes everything so much clearer." "I didn't believe I could do this!" These are the typical reactions from students, and the reason for this book. All I can add is, "Happy painting!"

Chapter 1

CHOOSING AND USING
MATERIALS

W atercolor paintings have a definite appeal, and so do the materials we use to make them. We covet the latest brushes, pigments, and papers, but there are more supplies available than one artist could master in a lifetime.

In many ways, this is an advantage. No two artists paint exactly the same way. We approach the painting process differently, and our styles are unique. Obviously, the materials we need will vary. Experimenting with various products encourages us to find new ways to use the medium.

It is tempting to try everything. This makes it all too easy to become a collector of art supplies. Success with watercolor depends on having the materials that do exactly what we ask of them, and then practicing with them repeatedly. The fluid nature of watercolor prompts us to make decisions quickly, so we want to use our materials as effortlessly as possible. Working with a limited number of supplies gives us this edge.

There are materials that will do what we ask of them. These become our workhorses. Other products may tempt us because they are new, or exciting, or because another artist gets good results with them. The tools that make a real difference are those that help us do *our* job better.

We often collect too many supplies to use them effectively.

How to Choose Supplies That Work

Today there is ample information about the cost, quality, and availability of watercolor supplies. We follow the trends and ask for advice from other artists. Even so, we envy artists who seem to unearth tools that perform like magic. This happens because we forget to ask the "how" question: how these materials will help us reach our goals.

Describing something specific that we want to achieve—to mix colors, paint intense darks, or layer washes—takes us a long way. Once we have a goal, finding the supplies to make it achievable becomes common sense.

The materials that artists choose—including yours truly—are less important than *how* they are useful. With this in mind, the information that follows provides some answers to the "how" questions.

Winifred Breines,
***Peppers in White China Basket**,* **13" × 16½",**
watercolor on paper.
This watercolor features smooth shapes and a careful selection of bright and subtle colors. The choice of materials reflects the artist's intentions.

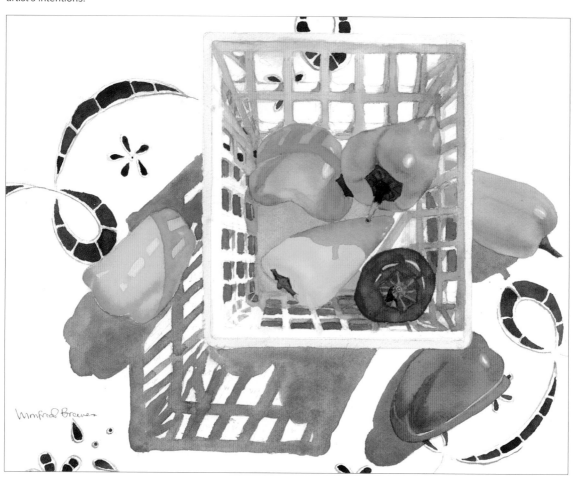

The Basics of Brushes

We can predict how a brush will behave by the way it looks. A wide brush with a square end will deposit paint differently than a small round brush with a pointed end. The size and shape of a brush will influence how we use it.

1-inch Flat Brush

A flat brush has a wide, flat surface that is perfect for big washes of paint. It can cover a large area rapidly, so it typically sees a lot of use. One pass with this brush creates a broad line. The narrow edge and tip make thinner strokes. Flats produce solid, blocky shapes, and they are available in a variety of widths.

#10 Round Brush

A large round brush is another workhorse. It can quickly build massed shapes, and the point is handy for smaller ones. Round brushes make fluid, organic lines that more easily capture the curved or irregular forms seen in nature.

#7 or #8 Medium Round Brush or ½-Inch Flat Brush

Medium-sized brushes are especially handy for painting intricate shapes or edges that require some measure of accuracy, but patterns of smaller brushstrokes also make a subject more lively and interesting.

#3 or #5 Small Round Brush or Liner

Small round brushes and liners are used to make delicate strokes of color. They most often come into play after the larger masses and lines are established. A liner is a round brush with long fibers cut to form a square tip. This flexible brush makes fine, spirited lines.

The demonstrations identify the type of brushes used, but this explains only how the results were achieved. Brushes are a personal choice.

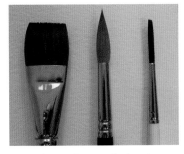

From left to right are a flat brush, a round brush, and a liner. The shape and length of their fibers suggest how they might behave.

Flat brushes make strokes of different sizes; each side of the brush is a different width.

By changing the amount of pressure on a round brush, we can make marks as fine as its pointed tip or as wide as its belly.

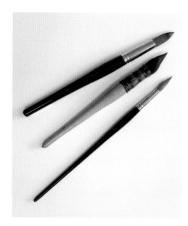

These three brushes are similar in shape, but their fibers behave differently. From top to bottom, the brushes are synthetic, squirrel, and a natural fiber referred to as sable, although it is gathered from a different animal.

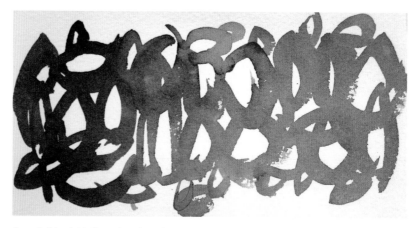

From left to right, these brushstrokes were made with a synthetic, squirrel, and sable brush on a moderately textured paper. Synthetic fibers tend to make smoother, more even brushstrokes, while natural hair is more likely to produce varied edges.

Brush Fibers

Synthetic brushes tend to produce regular, rhythmical strokes with smooth edges. The marks they make may not be as varied as other options, but the results are pleasingly decorative. Synthetic brushes are often modest in price.

Squirrel hair has a soft, relaxed quality that naturally fits a loose approach to watercolor painting. Round brushes made from squirrel are referred to as mops, a term that aptly describes their action on paper. Sable is a springy hair that is both resilient and flexible. Natural hair brushes readily create marks with both smooth and rough edges on watercolor paper. These do tend to be more expensive, but smaller sizes are generally affordable.

Manufacturers also experiment with combinations of natural and synthetic fibers to make brushes that are more sympathetic to watercolorists.

OPPOSITE: Frank Webb, *Taxco*, 30" × 22", watercolor on paper. Flat brushes transform the buildings, cars, and figures into a lively geometric pattern. Repeating the chiseled shapes and smooth edges unifies this complicated subject.

HOW TO CLEAN WATERCOLOR BRUSHES

1. After wiping the brush clean on a soft cloth, rinse the tip in cool water.

2. Gently work suds from a bar of mild soap through the fibers and up into the heel of the brush to remove the paint.

3. Rinse the brush again and gently shake to remove excess water.

4. Coax the brush fibers into shape and store upright.

A brush should never be left soaking in water. This will deform the hair, loosen the ferrule, and cause the finish to chip off the handle.

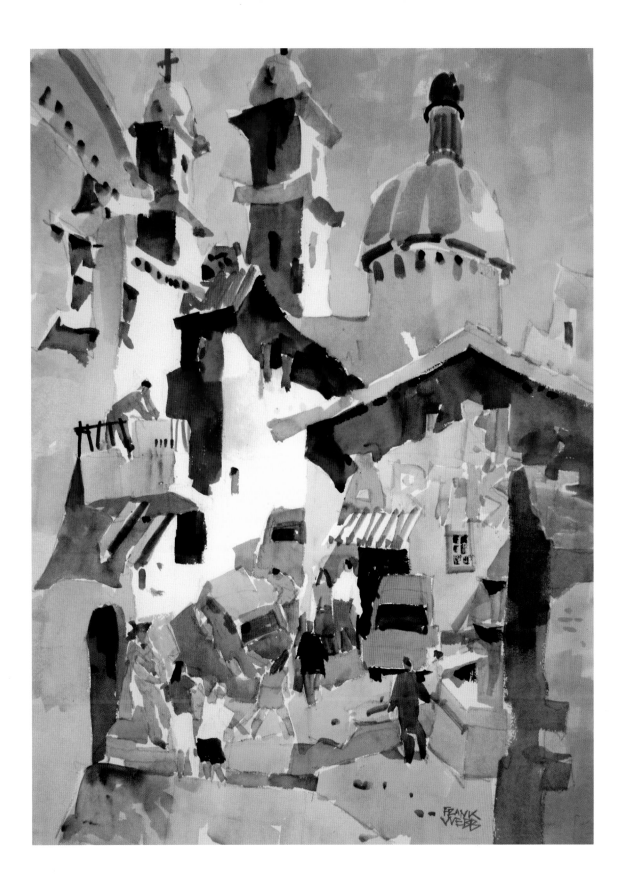

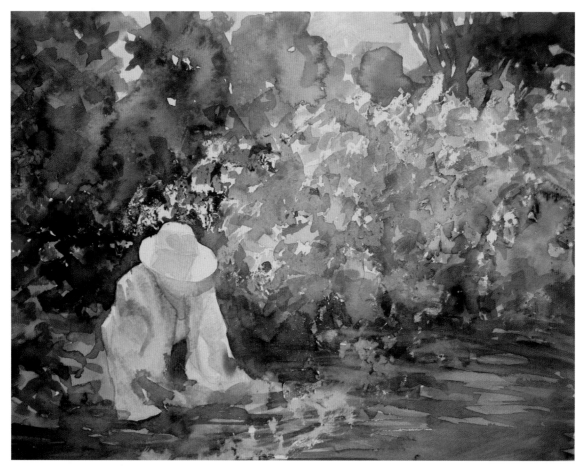

Ron Lace, *The Gardener's Art*,
13¾" × 17¾", watercolor
on paper.
The artist chose round brushes
to express the natural forms of
flowers and foliage.

Setting Up a Palette

One large palette keeps our paints readily available. An undivided space
is ideal for mixing large and small puddles of color. A cover keeps the paint
in a more workable condition. A small spray bottle is useful for moistening
dry pigments.

Where to place pigments on a palette is a matter of personal choice, but
many artists use an arrangement similar to the one in the photo, opposite.
On this palette, the pigments are grouped by hue and brightness; the hue
is the color family. Duller brown or gold colors are grouped together in the
bottom right: burnt umber and raw sienna. The yellows are in the upper
right, the reds across the top, and the green and blue colors are on the left.

There is a big advantage to consistency. It is easy to find the pigment needed
instantly. As soon as a color comes to mind, we know where to reach.

Choosing Pigments

Many pigments are available, and the list continues to grow. Gems, earth, minerals, seashells, plants, and chemical compounds are all sources for artists' pigments. Although the sources vary, they are physical substances with known qualities that reliably make specific hues.

Artists' pigments are milled to be as consistent as possible, so we can rely on our paints to behave the same way every time we use them. This makes choosing pigments one of the more systematic aspects of painting.

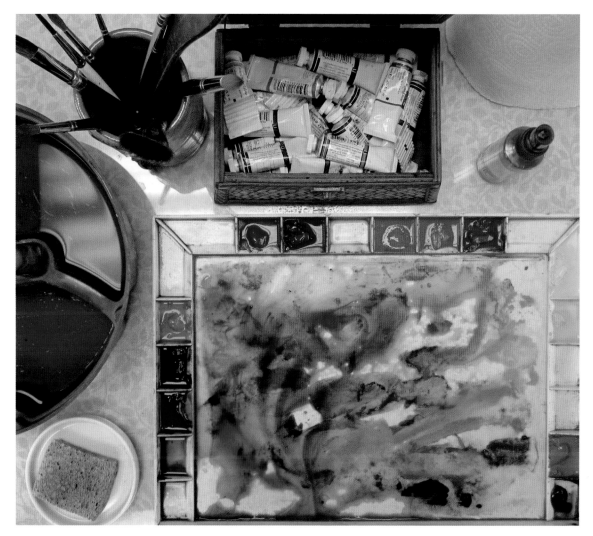

A basic set of supplies fits in a small space, keeping everything within easy reach.

Watercolor Paint

Tubes of moist pigments easily provide enough color to cover a large passage of paper, and the fluid paint is far easier on our brushes than the dry paints that come in pans. Tube watercolors are sold individually in student and professional grades. The student-grade watercolors are less expensive and generally contain less pigment for the volume of water. Manufacturers may also use less expensive pigments in their student-grade paints. A cadmium yellow "hue" will look like cadmium, but it may not perform in exactly the same way.

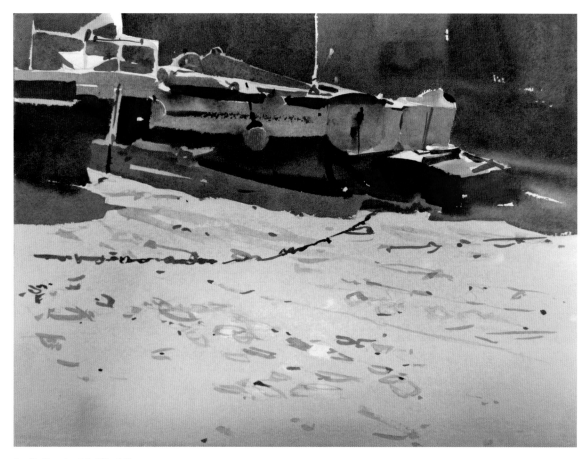

Leslie Frontz, *Aft*, 11" × 14", watercolor on paper.
The higher concentrations of pigment in professional-grade watercolors make it easier to obtain dark, juicy colors, an important consideration when purchasing paint.

The Limited Palette

With a small number of pigments—a limited palette—it is far simpler to master the mechanics of color. We learn more about mixing colors when we use the same pigments repeatedly. Yellow and red make orange. Burnt umber and phthalo blue make green. Indian red and ultramarine blue make dull violet. We *remember* what happens when we mix the same combinations repeatedly. A well-chosen selection of colors—even a small assortment—makes it possible to paint any subject we might imagine.

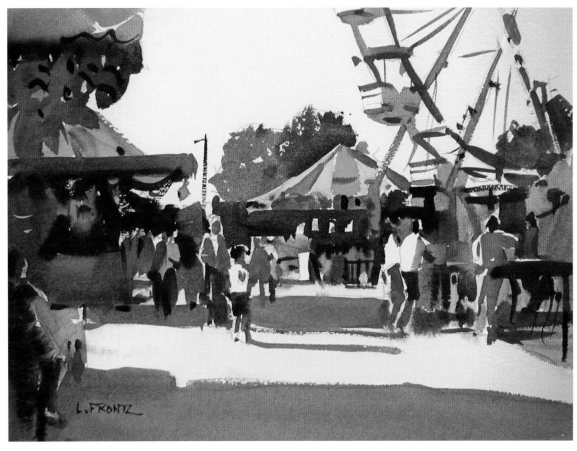

Leslie Frontz, *County Fair,*
8½″ x 11½″, watercolor on paper.
This colorful painting was
painted with twelve pigments.
A large supply of paints
is not necessary to create
a vibrant watercolor.

From red, yellow, and blue, we can mix many other colors. Our palette of colors will contain two yellows, two reds, and two blues. Having two versions of these three hues significantly extends our range of mixing options.

As few as six pigments can do most of the work. From left to right, they are cadmium lemon, cadmium yellow, cadmium red, alizarin crimson, ultramarine blue, and phthalo blue.

Our palette also includes earth colors: pigments taken from earth, clay, or minerals. Raw sienna is a light golden brown. Burnt umber is a dark, warm brown. Indian red is a dull, warm red. These mainstays are also good mixing colors.

The lessons in this book also make use of three warm neutral pigments. From left to right, they are raw sienna, burnt umber, and Indian red.

In our setup, the addition of a few intense colors makes it possible to capture any subject. Quinacridone rose, a relative of alizarin crimson, provides a brighter pink. Phthalo green is a clear, bright, transparent blue-green. Cobalt turquoise is a bold, light green-blue with a little more body than many other watercolor pigments.

Quinacridone rose, phthalo green, and cobalt turquoise provide three bright hues to fill in any small gaps on the palette.

Our choice of subjects will sometimes dictate a change of pigments. The idea is to rotate our selections as needed instead of overloading the palette.

Black is not used in the demonstrations, but it is useful to have on hand for some of the other projects in this course. A small tube of a less expensive student-grade black pigment is all that is needed.

White and Light Shapes

In watercolor, white is the color of the paper: to make white or light shapes, we learn to paint around them. Any small or delicate whites or highlights can be indicated with strokes of opaque watercolor. Using a resist is also an option for preserving whites. All have advantages and disadvantages, so it is a good idea to know how to use each technique.

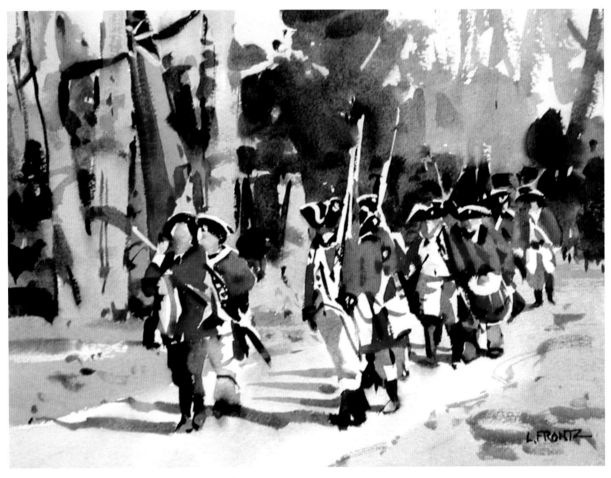

Leslie Frontz, *Living History*, 8½" × 11½", watercolor on paper.
In transparent watercolor, we learn to think about white shapes as unpainted shapes. The white passages in the reenactors' uniforms are the white of the paper.

Bernard Evans, *Slip, Cornwall*,
11½" × 14½", watercolor on paper.
British watercolor artist Bernard
Evans flawlessly captures delicate
lights with opaque gouache.

White Gouache

Small or delicate lights can also be captured with strokes of gouache, which
is an opaque form of watercolor. Gouache makes it possible to place touches
of light paint over dark, but it has limitations. Up close, even a modestly
sized shape painted with gouache will be noticeably more opaque than the
surrounding passages of watercolor.

To avoid contaminating transparent watercolor pigments, it is best to place
a small amount of white gouache in a separate container. It can also be
loaded directly onto a clean brush straight from the tube.

Masking Fluid

Some watercolor artists use a rubbery masking fluid instead of painting
around white or light shapes. When dry, the mask resists the watercolor paint.
Removing it reveals white paper. These gummy solutions dry quickly and
are difficult to remove from a brush. Working some gentle soap into a brush
before use makes it easier to remove the masking fluid.

A liquid resist can be used to mask
out areas that are to remain unpainted.

Watercolor Paper

Professional-grade papers hold color well and have a resilient surface. They are made from cotton, and this "rag" content makes the paper very durable. We can apply multiple layers of water and paint without causing any damage. Student-grade watercolor papers are typically not 100 percent cotton. They are less expensive but not as forgiving.

There are many reliable brands of professional papers. On a quality paper, pigments look bright and transparent; dark passages remain luminous.

Paper Size

The standard size for a sheet of watercolor paper is a generous 22 × 30 inches. Using whole sheets, half sheets, and quarter sheets is a convenient practice, but the size and proportion of the paper should suit the subject.

The demonstrations in the book use quarter sheets, but this simply allows us to get the most mileage from our paper supplies while learning how to paint. On a professional paper, we can paint on both sides.

Paper Surface

Watercolor paper is typically available with three different surface finishes. Hot-pressed paper has a hard, smooth finish, and rough paper has obvious hills and valleys. Cold-pressed paper falls between these two. Each one behaves differently. Rough paper has sufficient texture to make a brush skip over its surface, leaving small highlights on the paper. Paint tends to puddle on the smooth surface of hot-pressed paper. Cold-pressed paper is a popular choice, allowing for brushstrokes with even or irregular edges.

Paper Weight

Watercolor papers are described by their weight. The most serviceable papers range from 140 to 300 pounds. A few mills offer intermediate weights. All have a sturdy, responsive surface.

Papers vary from brand to brand, so it is important to remember that if one does not suit us, others are available. If colors look dingy or darks look dreary, using a different paper may provide the solution.

Supporting and Stretching Paper

The position of a work-in-progress can be easily adjusted when it is attached to a painting board. We can change the tilt of the board or move the watercolor to another location on our table or easel. Painting boards are available in tempered hardboard or plastic. One-half-inch hardwood plywood is a durable option available from home supply centers, and it can be cut to any size.

Our choice of a painting board depends largely on how we will fasten our paper to it. Not all papers lie flat when wet, so this decision merits some thought.

Working with Wet Paper

A 300-lb. watercolor paper will remain flat. This in itself is an attractive quality. We can draw the subject on the paper and begin painting. Ease of use makes the heavyweight paper an attractive choice, although it does cost more.

Lighter weight papers will all buckle when wet. There are three strategies for dealing with lumpy paper: we can ignore the buckles, smooth out the buckles as they form, or stretch the paper.

Paint tends to glide off the swollen spots, so the buckles can be difficult to ignore. We can use heavy-duty clips to clamp the paper to a board. As buckles form, the clips can be moved to smooth the paper. This method is by no means foolproof.

We can also stretch the paper to prevent buckling. This is a simple process: wet the paper, let the fibers expand, attach the paper securely to a board, and give the paper time to dry and shrink. Commercial stretching systems are available, but each set of stretchers will accommodate only one size of paper. Using gummed tape to hold the paper on a board is not very reliable, as the tape all too often releases its hold.

A tacker gun, a lightweight version of a staple gun, easily secures watercolor paper to a wood board. When cut to size, the board should be a few inches taller and wider than the size of the paper to be stretched.

HOW TO STRETCH PAPER WITH A TACKER GUN

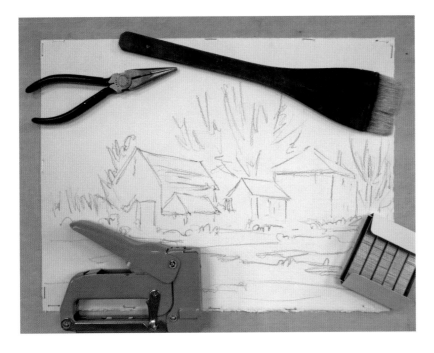

Using a tacker gun is a dependable method of stretching paper. The supplies needed are minimal: a tacker gun, tacker staples, needle-nose pliers, wide brush, water, and a wood painting board.

1. Use a 2- to 3-inch flat brush with soft fibers to moisten an area on the board larger than the paper. An artist's hake or varnish brush works well for this purpose.

2. Rinse the brush thoroughly, and use it to wet both sides of the paper. Some artists prefer to dip the paper in water or apply water with a natural sponge.

3. Position the wet paper on the wet board.

4. If there are any raised areas on the paper—these indicate air bubbles trapped underneath—lift the paper and add more water to the dry spot.

5. Let the paper rest for five minutes, allowing the cotton fibers to expand.

6. Staple the paper to the board. For a quarter sheet, three evenly spaced staples along the shorter sides and five on the longer sides should do. The outermost staples also secure the corners.

7. When the finished painting is dry, remove the staples with needle-nose pliers.

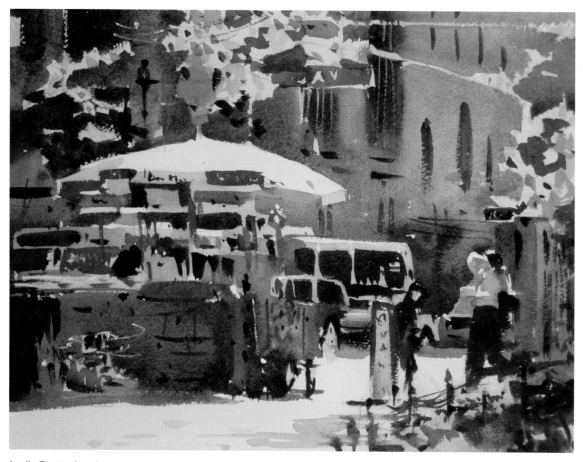

Leslie Frontz, *Lunch on 5th Avenue*, 8½" × 11½", watercolor on paper.
There are many fine papers, but Saunders Waterford, my personal favorite, allows bold, luminous darks.

Studio Supplies

There are items other than studio supplies that are essentials in a complete watercolor tool kit.

Drawing Pencils and Sketchbooks

The lines made by a standard writing pencil are seldom dark enough to be seen clearly through substantial layers of pigment. Drawing pencils graded with a number followed by the letter B are softer and make darker lines. The numbering system is not entirely consistent across brands, but a 4B drawing pencil is a serviceable choice. To make lines lighter or darker, simply change pressure on the pencil.

A small sketchbook is a handy tool for making a record of what interests us. Drawing allows us to get quickly to the essence of objects: the curve of a branch, the proportions of a building, or the pose of an animal. Sketching helps to consolidate our thoughts about a potential subject.

Erasers

The rectangular white plastic erasers available as office supplies are my favorite choice for correcting drawings on watercolor paper. They are durable, longlasting, and do not damage the paper.

Synthetic and Natural Sponges

There is water in the paint, often some on the paper, and even more in our brush. Shaking water from a brush spatters diluted paint everywhere. As an alternative, we can rinse the brush and touch it to a damp household sponge to remove excess water.

A natural sponge can remove some pigment from watercolor paper without damaging its surface. Wet the paper with a brush, gently massage the offending passage with a dampened natural sponge, and blot the paint up with tissues. When dry, fresh paint can be applied to the treated area. Some pigments will resist lifting, but this technique works amazingly well on professional watercolor papers.

After rinsing a brush, touch its tip to a damp sponge to remove excess water before loading fresh paint. This practice produces color mixes that are saturated with pigment.

Hair Dryer

To speed the drying time, a lightweight hair dryer with variable temperature and speed settings is a useful item to have available, especially when we are trying to squeeze in a painting session between other obligations.

REDUCING THE DRYING TIME OF A WASH

Watercolor paper must retain some natural moisture to perform at its best. To avoid dehydrating the paper with a hair dryer:

1. Use a low- or no-heat setting on the hair dryer.

2. Aim the stream of air obliquely across the surface of the watercolor paper, not right at the paper.

3. Use the back of your hand to test the paper; it should feel dry but cool to the touch. Another clue about the amount of moisture in the paper is its appearance. Wet paper will glisten, but damp paper may look dry.

Studio Space

A small space makes a fine studio. Mine has room for a substantial watercolor easel. A small table could be used here instead. A wooden utility cart holds the painting gear that sees consistent use: palette, paint, and my favorite brushes. Supplies that see less frequent use are arranged in a mobile shelf unit. There is still ample room for bookshelves, as well as a chair for comfortable reading.

An armoire houses more supplies: sketch papers, framing materials, and outdoor painting gear. Sheets of watercolor paper fit behind it. A small flat file holds unframed watercolors and studies. With this arrangement, a closet is not necessary.

The central workspace receives ample light from overhead fixtures, and there is natural light from windows at each end of the studio. Narrow shelves along one wall keep framed paintings on view; no nails are required, and the display can be changed in a matter of minutes.

A studio does not have to be large or elaborate to be effective. Good light is the only requirement, and fluorescent fixtures with color-corrected bulbs will compensate for limited natural light. An inexpensive area rug will protect flooring or carpet. A pleasant, comfortable space will see the most use. There are few good excuses for not finding a place to paint.

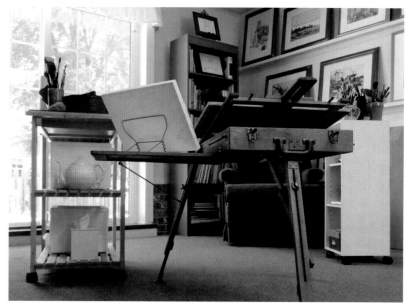

I share a studio with my husband, an oil painter. My space measures only 12 × 14 feet, but it provides enough room for far more than the basics.

The Work Surface

Most watercolor artists paint on a horizontal table or easel. Watercolor is wet, so the work surface should be able to withstand a soaking. Its size depends on how large we want our watercolors to be.

Standing at a table or easel provides a much better view of our painting in progress. Brushstrokes can be freer and more gestural when the muscles of the shoulder and arm—instead of the fingers—move the brush.

There are other strategies when standing is not a practical choice. A tall stool is a better seat than a low chair. A lower painting surface is another option. Both provide a more direct line of sight.

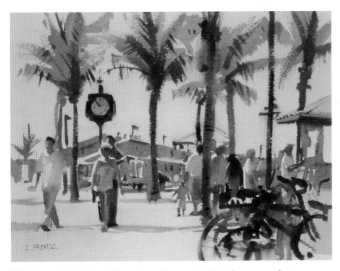

This is a typical view of a watercolor on a table when seen from a standing position.

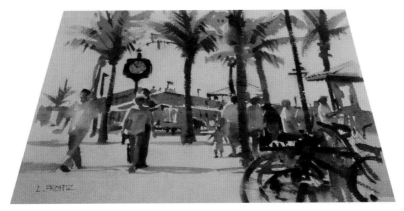

This is a view of the same watercolor from a seated position. The line of sight is oblique to the surface, and the distortion is significant.

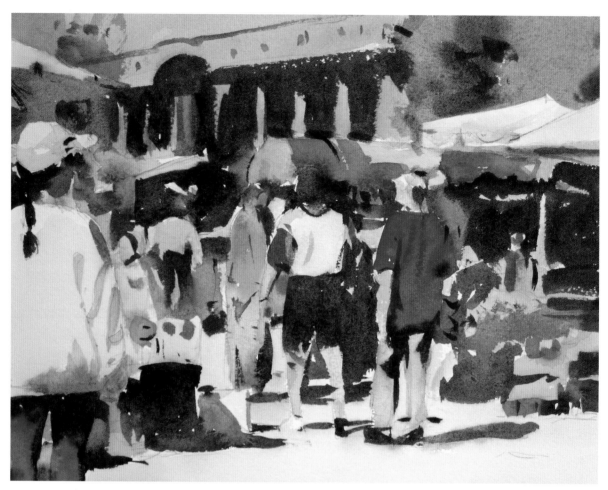

Leslie Frontz, *Street Fair, Santa Fe*, 11″ x 14″, watercolor on paper.
Our choice of materials is dictated by what we want to achieve: in this watercolor, bold light and dark contrasts, strong color notes, and varied edges.

Reference Photographs

Each demonstration in this book includes a photograph of the subject. The point is not to learn how to paint from photographs, but to learn how to capture what makes a subject interesting to us. Being able to share the idea that inspired each demonstration makes this possible. To make substitutions for these references, look for subjects that are arranged in much the same way. A similar pattern of shapes—the basic layout or design—is more important than the actual subject.

Painting from photographs does have some drawbacks. A photograph represents a single glimpse of a subject. Our own view is a composite. To sketch a street scene, we might begin with a glance at the doorways and awnings directly across the way. Lifting our head slightly allows us to see the middle floors. By raising our line of sight again, we can take in the roofline. Only then do we piece the data together to form a mental image of the view. *We experience a subject as much as we see it.* A camera cannot do this.

The camera has other limitations. A lens is not sufficiently sensitive to nuances within dark areas. Photographs also distort the size and proportions of objects. The colors may not be accurate. Perhaps most important, we see things subjectively, attaching meaning and significance to objects.

The photo references used in this course simply make it easy to share information about how to translate something we see—or imagine—into an accomplished watercolor painting. The "how" includes many things, from seeing the shapes in a subject to expressing a mood. We want to think like an artist: to arrive at the point where the process of seeing, thinking, and doing is seamless.

Supply Checklist

A checklist makes it easier to sort out what we have on hand and what we might want to buy to complete our toolkit:

Brushes

1-inch (large) flat brush

#10 (large) round brush

#7 or #8 (medium) round brush or ½-inch (medium) flat brush

#3 or #5 (small) round brush or liner

Paints and Paper

Cadmium lemon

Cadmium yellow

Cadmium red

Alizarin crimson

Ultramarine blue

Phthalo blue

Raw sienna

Burnt umber

Indian red

Quinacridone rose

Cobalt turquoise

Phthalo green

White gouache (optional)

Small tube of student-grade lamp or ivory black

22 × 30-inch sheets of professional grade watercolor paper

Studio Supplies

Lidded palette with large mixing area

Table or easel

Painting board

4B drawing pencils

Pencil sharpener

Masking fluid (optional)

White plastic eraser

Small sketchbook

Household sponge

Natural sponge

Hand towel

Hair dryer

Paper towels and tissues

Small spray bottle

Binder clips

Supplies for Stretching Paper

2- or 3-inch hake or other flat brush

Lightweight tacker gun

Tacker staples

Needlenose pliers

Wood painting board

Summing Up

With a small number of trusted supplies, any subject we wish to tackle is within reach. Finding the right brushes, paint, and paper for our needs allows us to concentrate on our painting instead of our supplies.

Leslie Frontz,
Beach Buddies, 13½" x 21",
watercolor on paper.
The beach buddies form a set
of small, interconnected shapes
painted with three brushes
and twelve pigments.

Chapter 2

INTERPRETING SUBJECTS AS
SHAPES

W hile materials and techniques are important, it is our choice of a subject that determines how we put brush to paper.

Watercolor painting is a visual translation. We see things that inspire us to represent them as shapes on a sheet of paper. This is a skill we learned at an early age: an orange is round. A window is a rectangle. Making shapes that stand in for objects lets us share our vision of the world with others. We see small ovals below triangular shapes and interpret them as people at an outdoor café.

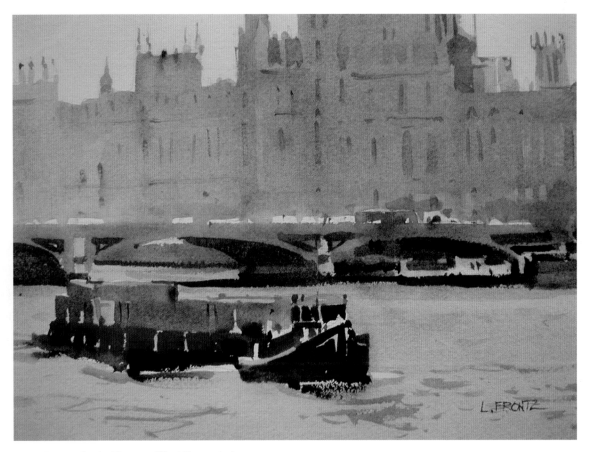

Leslie Frontz, *On the Thames*, 11" × 14", watercolor on paper.
Translating a pattern of shapes makes a solid foundation for a watercolor painting. This scene features a dark barge and bridge against lighter forms.

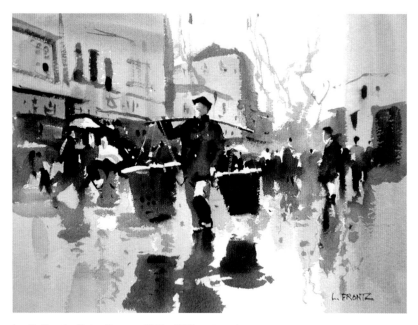

Leslie Frontz, *Rainy Season*, 8½" × 11½", watercolor on paper.
This image features pedestrians moving along a busy street and reflections from the buildings above.

A change in view reveals a crowd of pedestrians as a shape that travels horizontally across the paper. A wide, pale vertical passage extends from top to bottom.

Shapes like these are powerful visual cues. Basic silhouettes allow us to identify *objects*, and we find no reason to look at shapes in greater depth.

To put materials to good use, we want to see with an artist's eye: to see the structure of a *subject* and describe its qualities with paint. To do this, we learn to think about shapes in a new way.

This chapter introduces the basic techniques used to capture shapes in watercolor. Just as important, it explains how an artist's response to a subject influences decisions about materials and methods. This approach allows us to apply paint to paper and end up with a work of art.

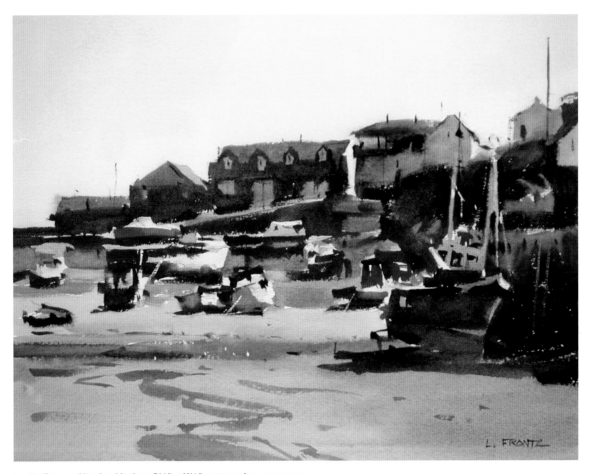

Leslie Frontz, *Newlyn Harbor*, 8½" × 11½", watercolor on paper.
The harbor is filled with buildings and boats. As a shape it is a dark area punctuated by light spots.

Searching for Shapes

When we see a subject in bits and pieces—an umbrella here, people seated at a table there—we paint it this same way. It becomes difficult to spot how the pieces fit together to form the shapes that really count.

To see with an artist's eye, it is necessary to look for the unifying shapes instead of cataloging individual items. This cannot be stressed too much: *we must look beyond objects*. The arrangement of shapes tells us how to organize and paint a subject.

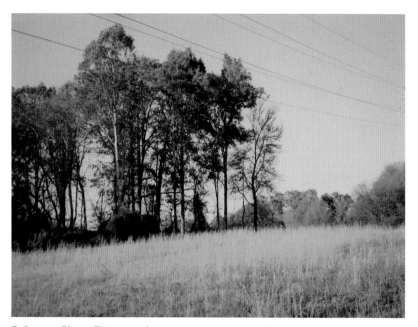

Reference Photo: This scene features autumn trees cresting a ridge. A subject that can be described with few words can usually be painted as a few simple shapes.

A Tree Shape

In this scene, the *trees* form a large, dark mass. It has lacy edges and bold, warm colors. The *sky* breaks into its interior, but we can still readily see the trees as one big shape. The *field* falls in between: warmer and darker than the sky, but not as striking as the trees.

The words in italics are just a convenient way to describe these shapes. There are no trees, sky, or field: only shapes that create this illusion. When we paint, we want to be able to capture these qualities. Seeing and painting shapes is how we achieve this.

A Sky Shape

The sky shape contrasts with the dramatic tree shape. It is much lighter, and the colors are cooler and softer. The color transitions in the sky are subtle, grading gently from one hue to the next.

A Field Shape

The field shape is darker than the sky, but not nearly as dark and bold as the trees. Its variations in color and texture are subtle. They play a quiet role.

Seeing Shapes

Each shape in this subject has its own clearly defined character. We want to capture the effect of a light, cloudless sky. The tree shape will be dark and bold, with intricate edges and varied colors. The field is not as varied as the trees or as plain as the sky.

We choose materials and techniques that allow us to capture the qualities of the subjects that interest us. The sky and field can be simply defined. Large brushes are effective for this job. Round brushes will readily capture the irregular shape of the trees. Our versatile palette of pigments will provide all the colors needed for this subject.

Because watercolors are transparent, we traditionally learn to establish the lightest shapes first. The sky and field can be established with a large passage of color, called a wash in watercolor. We can add the tree shape when the wash is dry: dark colors over light ones.

Tree shape

Sky shape

Field shape

DEMONSTRATION: Carolina Autumn

The sky and field are painted with one continuous wash that will cover the entire paper. The qualities of the subject drive the choice of techniques.

STAGE 1

The first stage is a wet-into-wet wash: wet paint on wet paper. Stretched paper that is still wet is ready for painting. Dry paper is dampened using a large flat brush, the same brush used to paint the wash. The paper is laid flat so the pigment will not run downhill.

A large flat is an apt choice for this wash.

- A big, wet puddle of ultramarine and phthalo blue is mixed on the palette. This color is applied in broad strokes across the top half of the wet paper.

- Diluted alizarin crimson is added to the mix before the brush approaches the crest of the hill.

- Raw sienna, Indian red, and burnt umber are used for the field. The paint can be mixed on the palette or applied directly on the wet paper.

The tree shape will be crisply defined, but its interior will have soft transitions.

STAGE 2

When the first stage is dry, a wet-against-wet wash creates the trees. On dry paper, strokes of varied hues are placed next to one another. Where they meet, the colors merge. The outside of the shape has defined edges.

A large round brush is a good match for this subject and allows us to work quickly.

- The warm foliage is painted with dense but fluid mixes of alizarin crimson, cadmium yellow, and cadmium red.

- Shadowed foliage is added with mixes of Indian red and ultramarine blue.

- The trunks and twigs are single strokes made with the tip of a round brush.

- At the lower edge of the wash, a mix of burnt umber and phthalo blue suggests a lone pine.

To finish the watercolor, we paint around a shape: a path through the field. The path is the color already on the paper: We paint the field *up to* the edges of the path.

STAGE 3

When the underlying wash is dry, we can add a path through the field. The path is already the right color. We reveal it by painting around it. This technique—sometimes called negative painting—is a common practice when working with transparent paints.

A round brush easily makes broad and fine strokes, making it a good choice for the field.

- Simple shapes define the edges of the path. A mix of raw sienna, Indian red, and a small amount of phthalo blue is used to paint them. Slightly overlapping the base of the tree shape makes it unnecessary to fill in gaps along this edge.

- One small shape suggests a spot where the path is less worn. Lines added with a small round or liner finishes the painting

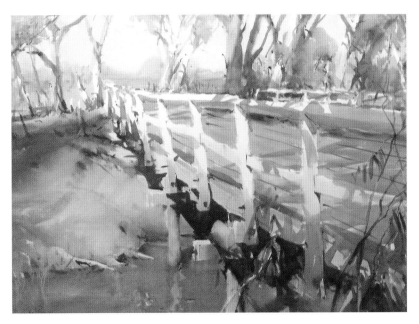

Ross Paterson, *On Honeysuckle Creek*, 20" × 30", watercolor on paper.
In watercolor, the art of painting around shapes is often put to extraordinary use.
The bridge is a complex shape perforated with many small darks.

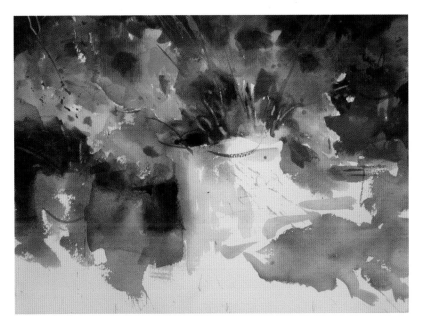

Sandra Carpenter, *Flower Power*, 15" × 22", watercolor on paper.
Two shapes—one light and one dark—can make a significant statement about a subject.

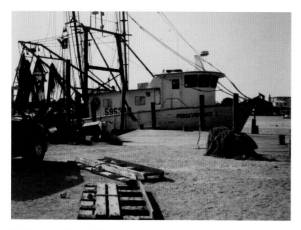

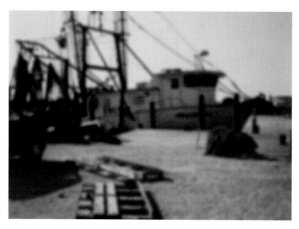

Reference Photo: The *sky* and *dock* shapes are relatively obvious. The rest is not so easy to describe.

Blurring a subject removes the visual cues that allow us to recognize objects.

Developing an Artist's Eye

Painting shapes prepares the way for success in watercolor. This is most often a straightforward proposition, but some subjects are harder to see as large masses.

Here we have a truck, a boat, nets, booms, rigging, a distant shoreline, and other gear that only a fisherman could name.

Blurring our view of the subject eliminates the details, making it easier to see this dark shape. Squinting softens our focus, but beware the wrinkles. This method is as old as the hills, but it works.

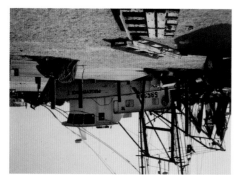

Turning an image upside down makes it more difficult to see objects and easier to see shapes.

Rotating an image also removes the cues that we use to identify objects, making it easier to see a subject as a set of shapes.

Calling this a "shadow" shape also makes it easier to see the miscellaneous collection of backlit items as a single form. What holds them together as a shape is that they feature dark, muted colors. The shadow shape is varied and interesting. It leads the viewer up into the painting, and then jogs to the left before ascending upward. The shape then swoops to the right edge before dipping slightly downward.

The result is a shape that interlocks with the sky and ground like a piece of a picture puzzle. When we understand how the puzzle fits together, we can see the shapes that make up this subject.

DEMONSTRATION: On the Docks

A highlighted area within the subject is treated as a negative shape, a common practice in a transparent medium. To give the shape a hard edge, the pigment must be applied on dry paper.

STAGE 1

With a wash on dry paper, we can paint around white clouds. Propping up the top edge of the painting will help move the wash downward. By grading the wash from blue to dull orange, we can complete the background in one pass.

A large round brush is a good choice for the sky. A large flat will quickly complete the dock.

- Pale blue is loosely brushed around the clouds. Their edges are softened in spots with clear water.

- The lower sky is painted with very pale alizarin crimson.

- A pale mix of raw sienna and Indian red is added to the hull. A darker version of the same mix is used to complete the wash, with care taken to paint around the highlight.

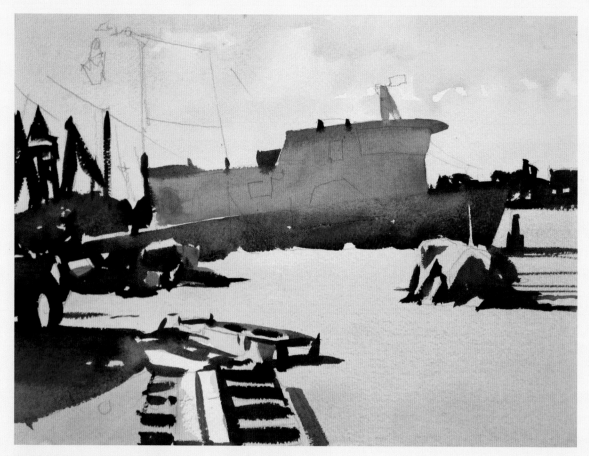

The shadow shape is painted wet-against-wet. We mix puddles of pigment, choose a suitable brush, apply the pigment, and allow the colors to merge.

STAGE 2

These next passages must be painted on dry paper to hold an edge. A wet-against-wet wash suits the shadow shape well. When we think through what we want to do, painting is quite simple.

This stage is painted with a large round.

- The lighter cabin is painted with more fluid pigment: ultramarine blue, phthalo blue, and a spot of alizarin crimson.

- Ultramarine blue, phthalo blue, Indian red, alizarin crimson, burnt umber, raw sienna, and cadmium yellow are used in the shadowy areas on the docks.

- When the cabin is damp rather than wet, a stroke of raw sienna mixed with burnt umber is added top and bottom.

- The dark blue hull is added below.

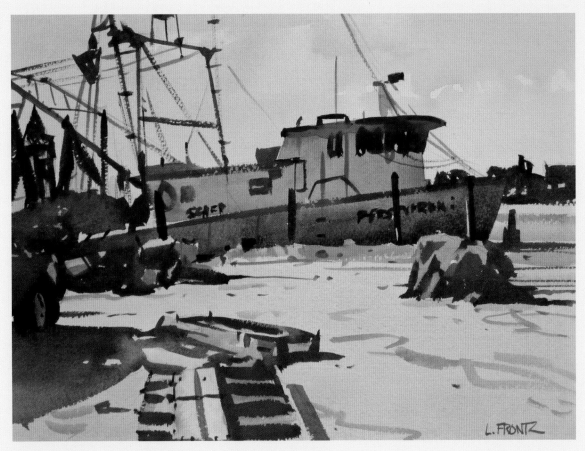

The hard work is already finished. These remaining brushstrokes suggest the details, and add character to the shapes.

STAGE 3

To finish up, we can describe the subject as precisely or loosely as desired. In this version, the rigging, pilings, nets, and other key elements are painted first. The rest of the "information" should be added to suit the artist.

Round brushes of all sizes are used in this stage.

- Two cobalt turquoise shapes and one alizarin crimson oval add contrast to the cabin. Raw sienna, burnt umber, and ultramarine are used for dark notes in this area.

- Both warm and cool colors are used to finish the fishing gear.

- Bright yellow and red notes add color among the shadows.

- Irregular strokes of paint create interest in the foreground.

Tom Hoffmann, *Quiet, Please!*, 13" × 17½", watercolor on paper.
A *deliberate* backrun breaks up the expanse of purple and suggests the wetness of
snow. It took one fluid stroke and considerable experience to create this virtuoso effect.

HOW TO MAKE BACKRUNS

Sometimes a watery brushstroke will
move pigment on the paper to a new
location. Like a ripple on the beach,
the paint leaves a track where it
subsides into the paper.

When painting a wash, timing is critical. If a passage of paint is not quite dry,
the addition of watery pigment may push any still-damp pigment aside. When
the pigment stops moving, it leaves a darker, irregular edge. This is called
a backrun.

Backruns often create flowing, circular forms, which explains why they are
sometimes referred to as blooms or blossoms. Some watercolor artists avoid
backruns at all costs, while others use them deliberately. Once we know how
they occur, we can decide which tactic is best for us.

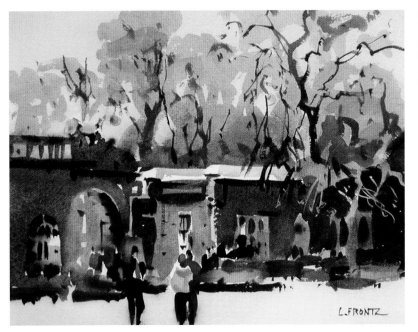

LEFT: Leslie Frontz, *St Cuthberts Mill*, 8½" × 11½", watercolor on paper.
As shapes, the trees and mill were designed to be the most eye-catching features in this painting.

BELOW: Charles Reid, *Favorite Artists*, 19½" × 28", watercolor on paper.
Each sketch in this series is a beguiling study of a famous painter. A simple pattern of shapes accentuates the pose and attitude of each sitter.

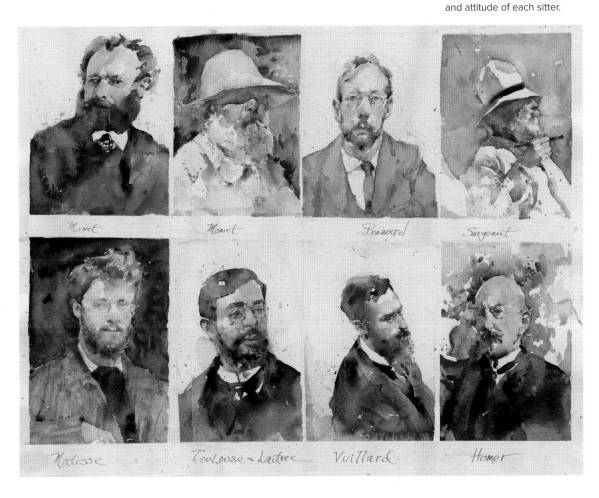

Arranging Shapes

The task of arranging shapes is what we mean by design. When we approach a subject as a set of objects, design seems to be an elusive and complicated task. Seeing the subject as a set of shapes instantly resolves this dilemma. Composition is simply the practice of organizing shapes.

Seeing the subject with an artist's eye makes design a simple matter. When we paint shapes instead of things, we are better prepared to asses their qualities and position them on the paper.

This still life is a case in point. The blinds, flowers, ceramic bottle, pot, produce, and even the shadows on the tablecloth could be connected to form a single shape.

In fact, the space around the shape could remain unpainted, and the composition would not suffer. This form of watercolor is a vignette. The shape touches the sides of the paper—or some sides of the paper—but leaves corners unpainted. Designing and painting vignettes makes us far more attuned to the placement and arrangement of shapes.

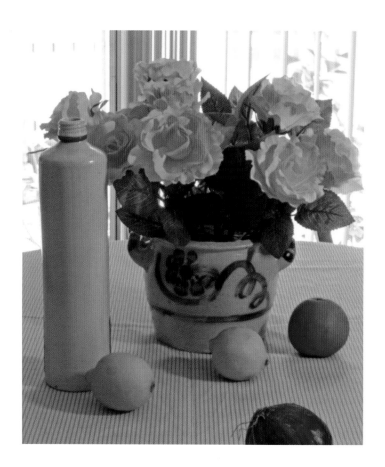

Reference Photo: This casual arrangement of odds and ends could make an effective composition.

HOW TO DESIGN A VIGNETTE

1. Decide where the most important feature or features of the painted shape will fall on the paper.

2. Determine where the shape will be anchored to the edges of the paper.

3. Evaluate the areas that will remain unpainted; in a traditional vignette, the corners.

4. Consider how the shape moves the viewer's eye into and through the painting: how interesting it is.

5. Examine the overall pattern and adjust as desired.

Leslie Frontz, *Looks Like Fun*, 9" × 13", watercolor on paper.
The massed shape in this watercolor is firmly attached to the sides of the paper, and three corners are free of decoration. The principles for vignettes work for any watercolor.

DEMONSTRATION: Shopping Day

Even items as varied as these can be treated as a single shape.

STAGE 1

This first stage links many objects, forming a shape that we can develop as a vignette. The colors are applied wet-against-wet, and the highlights are white paper.

A large round brush is a good choice for both the large and small passages within the wash.

- The blooms are quinacridone rose. The foliage color is mixed from raw sienna and phthalo green.

- Mixes of raw sienna, Indian red, and phthalo blue are used for the stoneware.

- The onion is alizarin crimson, Indian red, and phthalo blue. Three cadmium colors—lemon, yellow, and red—are used for the fruit.

- The cast shadows are ultramarine blue and Indian red.

Adding strokes of darker colors over dry pigment gives the shape more visual interest.

STAGE 2

Layering strokes of paint makes a lively surface and adds depth to the subject, particularly the pots and flowers. The goal is to suggest the volume of these forms rather than to copy them faithfully.

A large round is used in this stage.

- Pink and salmon hues are layered over the flowers.

- Mixes of Indian red and phthalo blue create the shadow falling across the pot; raw sienna provides some warmth in this area.

- Paler versions of the same pigments add more definition to the bottle and adjacent passages.

- Decorations on the pot are added with loose brushwork.

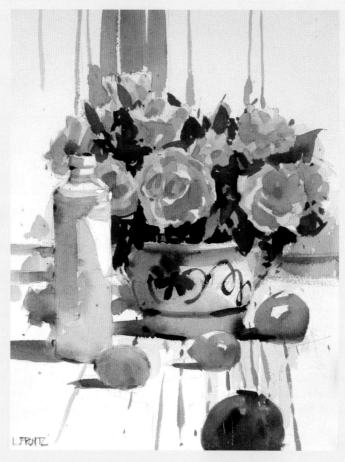

Linear brushstrokes complete the basic shape and add interest to its interior.

STAGE 3

Extending the shape to the top and bottom of the picture completes the vignette. Another layer of paint gives the subject more substance and adds to the illusion of depth.

A flat brush is used for the wide strokes above the flowers; the rest are painted with a large and medium round.

- A mix of raw sienna, cadmium yellow, and phthalo blue suggests the vertical blinds.

- Loose lines and spots complete the decorations on the pot.

- Phthalo blue and alizarin crimson are used to paint the stripes on the tablecloth.

Summing Up

Working with shapes allows us to see with an artist's eye: to see shapes instead of objects. Describing shapes gives us the means to simplify, improve, and arrange them in a more deliberate way. With a single step along this path, we are well on our way to mastering watercolor.

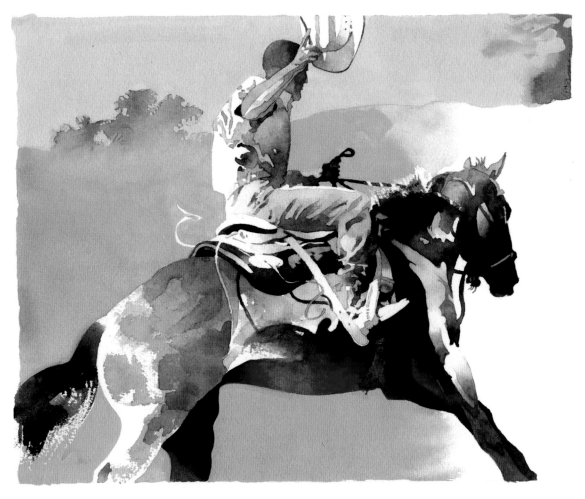

Don Weller, *Yee Haw*, 9½" × 12", watercolor on paper.
This watercolor emphasizes a unified shape that captures the strength, movement, and grace of the horse and rider. Decisions like these are not left to chance.

Chapter 3

PUTTING
VALUES
TO WORK

The concept of values is a simple one. Some things are lighter, and some are darker. Others fall somewhere in between. Values hold together the pattern of shapes that supports our paintings.

Leslie Frontz, *Still Life with Groceries*, **11" × 14", watercolor on paper.**
The pale background makes the colorful dark shapes stand out in high relief.
When values focus attention on a subject, painting it is much easier.

Cues are often necessary for us to perceive an object as being light or dark. Color distracts us from seeing values.

As easy as this may sound, seeing values is usually one of our least proficient skills. We learn to see an apple as red. Seldom are we asked whether it is light or dark. This leaves us with a dilemma. We often are paying more attention to colors, woefully neglecting values.

The photo on the left removes some of the color. The photo on the right decreases the value contrast. A single change produced each image.

Artists have passed on a valuable piece of advice: color gets the credit, but values do the work. The first photo to the left in the pair above is still striking. Removing some color did not weaken the shapes. Values manage to carry the picture. The version on the right is not as compelling. Reducing the contrast between light and dark has made the subject less noteworthy.

Making the Most of Values

Values build powerful shapes, and shapes hold our paintings together. A keen eye for values is essential in watercolor, which requires us to layer shapes from light to dark and paint around white passages. Artists use many strategies to observe values and paint values. Making a value scale, croppers, value studies, and thumbnail sketches all help us use values to best effect.

The Value Scale

A value scale is a series of paint swatches ranging from white to black. It is useful any time our observations are uncertain, but *making* a value scale is just as helpful as *having* one. It is the doing that makes the difference. The point is to learn how to mix the values we see in a subject. Painting swatches of different values is an unbeatable way to achieve this goal.

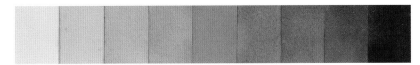

A value scale typically has five to nine evenly spaced steps that show a progression from light to dark. The center step is midway between the two extremes.

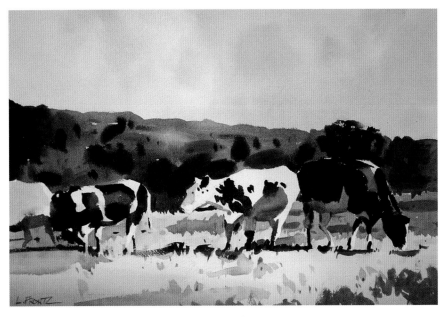

Leslie Frontz, *Luncheon on the Grass*, 14" × 21", watercolor on paper.
We are drawn to the Holsteins because of their contrasting light and dark spots. The background is more colorful, but the cows remain the point of greatest interest.

We can use the value scale to check values when working on location, from a sketch or study, a photo, or even from an earlier painting. It provides a series of checkpoints that help us determine whether our intended pattern of lights, midtones, and darks has been effectively translated onto paper. After making a value scale, some find their ability to paint values so improved that using the scale is seldom necessary.

With a little experience, we can *envision* the value we are mixing, *feel* the concentration of the pigment in our brush, and *see* the progressive difference as water is added to the paint. This is the essence of watercolor painting.

Leslie Frontz, *Champions*, 9" × 13", watercolor on paper. We see values in relation to one another. Surrounding the sunlit trees with dark tones brings the light passages into focus. Painting shadows creates sunshine.

HOW TO PAINT A VALUE SCALE

This project prepares us to think about *values* when we mix colors. Often we are so intent on matching a *color* that we don't consider how light or dark it really is.

1. Mark a quarter sheet (11 × 15-inch) of watercolor paper with 1 × 2-inch rectangles. Leaving a narrow strip of paper between the rectangles makes it possible to paint one swatch right after another: no waiting for the paint to dry.

2. Begin with the darkest value swatch. Mix black pigment from the tube with just enough water to make it flow smoothly, and apply it to the first rectangle.

3. Adding a small amount of water produces the next value. For this project, we try to make the difference between neighboring values equal.

4. We continue this process until the next value would be untouched paper. Painting the steps in sequence is extremely important, even if we do not use all the swatches.

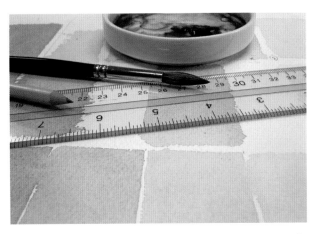

5. Once dry, all the rectangles are cut to the same size, eliminating any white borders. One additional rectangle is cut from unpainted paper. Lay the painted swatches out side by side so that they are in order: from white paper to the darkest value.

The swatches are painted as precisely as possible, but the results do not have to be perfect. Dexterity comes with practice.

6. A visual inspection tells us if the middle value is halfway between the white and black rectangles. There should be an even progression of values from one step to the next. The number of steps on the value scale can be five, seven, or nine: whichever seems most useful.

7. Blunders are easily fixed after the paint has dried. If a rectangle is too light, a wash is added. If too dark, wet the rectangle and blot it with a tissue.

8. The color swatches are pasted side by side onto sturdy paper or cardboard (a scrap of matboard works well). If the card buckles, place wax paper or plastic wrap on both sides and sandwich the value scale between heavy books. It should lie flat when it dries.

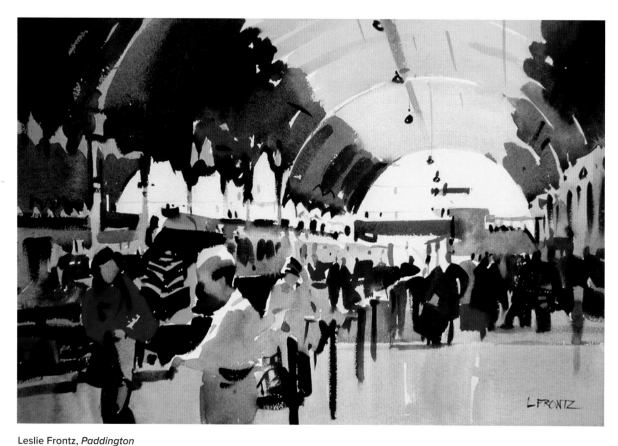

Leslie Frontz, *Paddington
Station*, 14" × 21",
watercolor on paper.
Values can make or break
a subject. The dark shapes
emphasize the light filtering
into the station. Strong
contrasts add a dramatic flair
to this everyday scene.

Keeping Shapes Intact

Values are often the most decisive quality of a painting. We can use values
to organize a subject into a legible pattern of basic shapes. This is not the
only way to employ values, but we make quick progress by looking for
broad passages of lights, midtones, and darks. We more readily spot their
arrangement and learn how to translate these relationships in paint.

Recognizing that adjacent objects of similar values function as a single unit—
as a massed shape—makes it easier to see and paint the pattern of lights and
darks. This practice also helps us to organize and unify our watercolors.

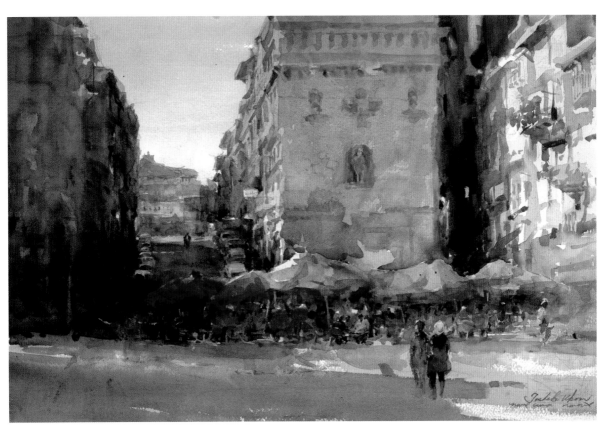

Toshiko Ukon, *Feel It, Heart*,
12" × 18", watercolor on paper.
This watercolor captures
the values with elegant
simplicity. We instantly
understand the subject and
respond to the effect.

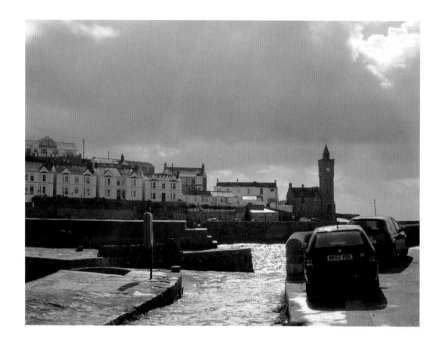

Reference Photo: This is not a typically pretty day on the Cornish coast. A sudden break in the clouds allows the sun to glimmer on shore and at sea, but the forecast is uncertain.

Observing Value Relationships

Learning to spot value relationships takes practice. The first demonstrations in the course led us through the task of identifying some simple patterns of light and dark shapes, but seeing values sometimes requires more thoughtful analysis.

Leslie Frontz, *Preliminary sketch*, 6" × 9", marker on paper.

In this subject, the glittering light creates striking value contrasts. The objects are clearly defined, but it takes a discerning eye to spot the arrangement of values. The light and middle values are not always where we expect them to be.

We intuitively think of white as the lightest possible color, but the white buildings above the harbor wall are *midtones*. The sky is darker than usual, but not dark. A passage that would typically be a middle value—the water—is instead a light shape.

DEMONSTRATION: Rain or Shine?

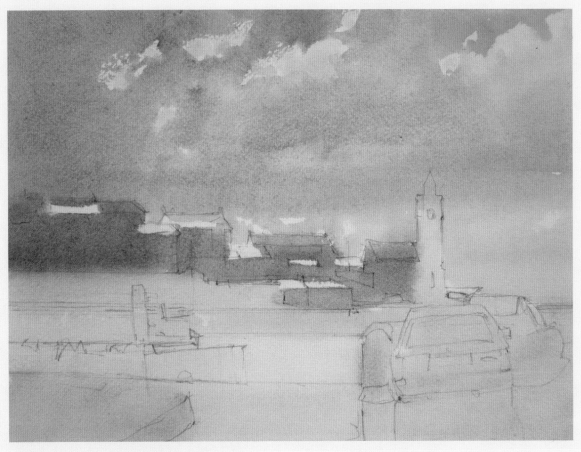

This passage of paint is darker above and lighter below, reversing the typical value pattern for a landscape.

STAGE 1

The first layer of color is painted on dry paper. Any passages that we want to remain white—at least for now—are left unpainted.

Using a large brush makes it possible to capture all the color changes quickly.

- The patches of blue sky are ultramarine and phthalo blue.

- The clouds are mixes of ultramarine blue, Indian red, and burnt umber. Nearer the horizon, they include raw sienna.

- The white buildings in shadow are darker versions of these same pigments.

- Pale raw sienna and Indian red color the sun-washed pavement, and the autos are pale blue.

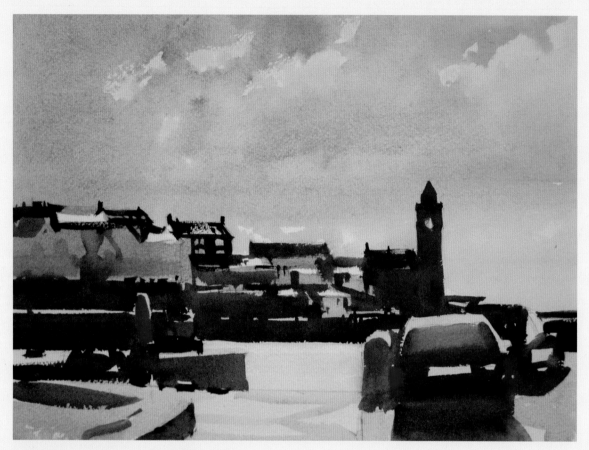

In this stage, we establish the dark shape: the upright planes that face away from the sun and any shadows they cast.

STAGE 2

This wet-against-wet wash is not demanding, but the shape is intricate. Some areas may seem challenging, but we are attempting only to convey an impression of the buildings.

The same pigments are used in this stage. A medium round will be useful for these smaller shapes.

- The first strokes of color define the rooftops and clock tower.

- The pigment is drawn down and around the small light and middle value shapes.

- The autos are dark, cool colors. Alizarin and cadmium red suggest the tail lights and harbor marker.

- Broad strokes of color indicate the uneven pavement.

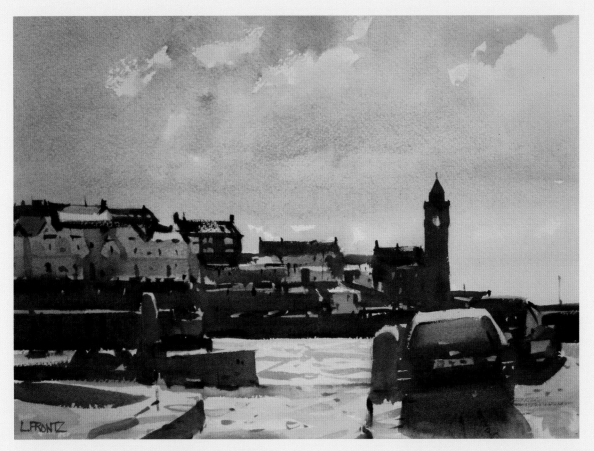

The remaining brushstrokes are largely dots and dashes. These interpret textures, suggest small shapes, and generally enliven the surface. The values have already identified the subject for us.

STAGE 3

Developing the broad value pattern first makes it easier to pick and choose what we want to add to a scene, as well as how precisely we want to identify these features. It is easier to recognize when our watercolor is finished.

Medium and small brushes are useful for these finishing touches, which are applied fluidly.

- The pavement is layered with strokes and spots of raw sienna. A little blue is added to the water.

- The license plate is cadmium yellow and raw sienna; abstract marks indicate the letters and numbers. The white spots on the car are washed with a mix of ultramarine and alizarin.

- Glints of light are painted with gouache.

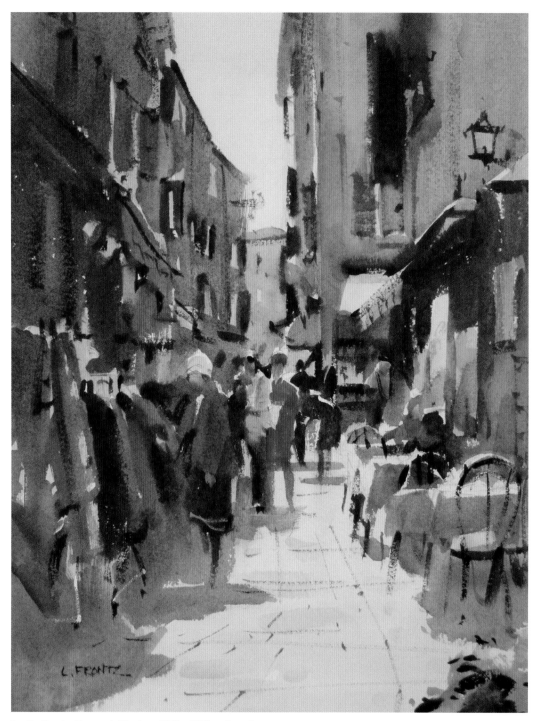

Leslie Frontz, *Souvenir Hunters,* **11½" × 8½", watercolor on paper.**
The converging light shapes draw attention to the figures.

Learning to see and paint values makes it easy to tackle more complicated subjects. Even figures are within our grasp.

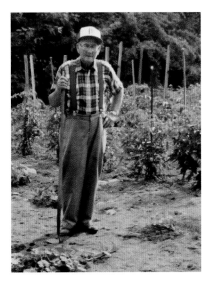

Reference Photo: The cropped image is promising. The figure fills the space in a more appealing way.

Enhancing a Value Pattern

Painting subjects that include figures helps us understand how artists use values to capture a likeness. No matter the subject, painting value relationships makes it possible to transcribe what we see with paint.

In the snapshot above, rim lighting around the head and shoulders makes the figure stand out against the shadowy foliage. The darker trousers and shoes read clearly against the sunlit garden soil. These contrasts make the gardener stand out, but the landscape dwarfs the figure.

Cropping a Subject

Interpreting a subject as a pattern of shapes and values makes it easier to improve its overall arrangement. Removing areas around the perimeter of a subject is a common strategy for creating more successful compositions. Artists refer to this as cropping.

Cropping a subject gives it a completely different structure. A set of L-shaped croppers helps us evaluate how to best present a subject.

HOW TO MAKE CROPPERS

Croppers are essentially two L-shaped pieces of cardboard used as an adjustable mat, so their sides must be long enough to surround a view or an image. Croppers work like a window frame. They isolate the area in which we are most interested, allowing us to preview our idea before putting brush to paper.

The size of the croppers is determined by our source material. When painting on location, pocket-sized croppers are very handy. When working indoors, the croppers may need to be large enough to accommodate a photo, sketch, study, or even an earlier watercolor painting.

Most watercolor artists have a few old mats on hand that are damaged or discolored. These can be cut in two to make a set of croppers. Even when starting from scratch, making a set of these cardboard croppers takes little effort.

1. Mark out two identical L-shaped pieces of sturdy cardboard or matboard to the desired size.

 For outdoor work, making each arm 3½ inches long provides us with a 2-inch viewfinder. The width of each arm can be as narrow as ¾ inch.

 For studio work, it makes sense to have a sturdier, more versatile size. An adaptable variation uses two L-shaped pieces of cardboard with the arms cut 2½ inches wide. The Ls each have one arm that is 14 inches long; the other is 20 inches long.

2. Cut out each section separately using a straightedge and a utility knife.

3. One side of the set of croppers is painted a midtone gray or beige. The other side is white. The white side works well on subjects that do not have a light-valued perimeter; the midtone side is more suitable for subjects that feature a very light or dark perimeter. Having both options allows us to form a clearly defined border around any subject.

Leslie Frontz, *Piazza*,
9" × 13", watercolor on paper.
In life, this was a street scene
with figures. After cropping,
the subject is transformed into
figures walking across a plaza.
Cropping can change the
focus of a subject.

Making a Value Study

Not all design flaws can be resolved by cropping. We suspect that removing some of the foliage might furthur improve this subject. Making a value study, a special kind of preliminary sketch, will help us decide whether what we have in mind is a sound decision.

To make a value study, we deliberately nudge similar values closer together, making a simpler pattern of lights, midtones, and darks. In this version, the left and right sides of the photo have been eliminated and some foliage removed. The figure now forms a more decisive shape within the picture plane. We can easily see the big shapes and how they connect to the picture plane.

Value studies are traditionally done in black and white, but dark brown is a good substitute for artists who prefer a warmer color. Paint, pencil, marker, and charcoal are all convenient for this purpose. No matter which materials are used, all value studies serve the same purpose: previewing a pattern of lights, midtones, and darks.

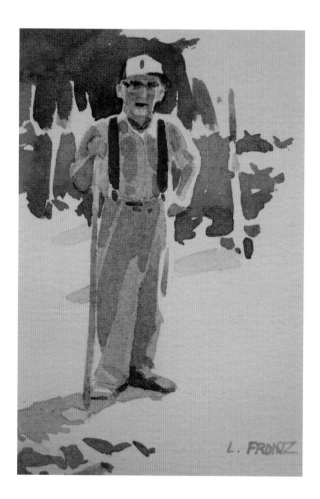

**Leslie Frontz, Value study,
6" × 4", watercolor on paper.**
A value study maps out the distribution of the lights and darks in a subject. It is a useful tool for previewing an idea for a watercolor painting.

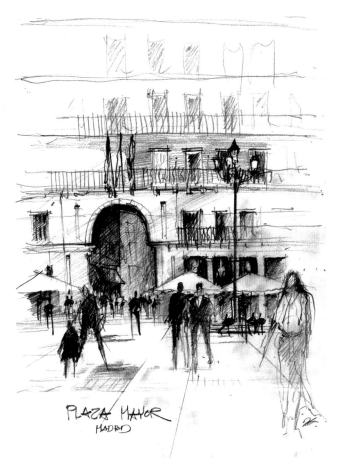

Jeff Good, *Plaza Mayor,* 9" × 7", pencil on paper.

Paul Tooley, *Nice Market*, 11" × 15", ink and vine charcoal on paper.

Leslie Frontz, *Restoration*, 11" × 14", charcoal on paper.

There are many ways to approach a value study. The result may more closely resemble a drawing or a painting. The best choice is the one that most helps the artist.

Leslie Frontz, *Port of Call,* 5" × 7", markers on paper.

DEMONSTRATION: Clyde's Hoedown

The lightest values are reserved for the figure and a few highlights.

STAGE 1

Portraits often lead us astray. We forget that a pattern of values suggests a subject more fluently than does painting its separate parts.

A large round brush is best for this task. Using one pigment allows us to stay focused on values. This wash is painted on dry paper.

- Lighter values of diluted burnt umber are loosely brushed around the figure, garden stakes, and lighter spots in the garden.

- Lower on the paper, darker values are added, suggesting the texture of the soil.

- While the paint is wet, hard edges in the wash can be softened with a clean, damp brush.

Broad passages of darker values bring the subject into focus. Diffused edges between brushstrokes of different values soften the contrasts.

STAGE 2

When the first stage is dry, a wet-against-wet technique is used to softly model the middle and dark values. There are no changes in color, but some strokes will be denser and darker. Others will be pale and watery.

Large and medium round brushes are used throughout this stage.

- Dark values are used to paint the trees; the varied edges identify this area as foliage.

- The shadow under the cap is a dark value.

- Middle values are used for the garden and the rest of the figure. All highlights are left unpainted.

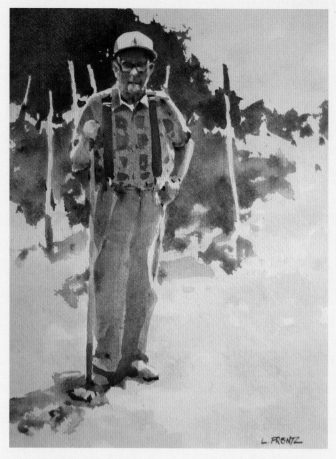

The addition of small touches of pigment identifies the subject.

STAGE 3

We can create a likeness by translating the broad value pattern and refining the nuances within it. Painting value relationships allows us to suggest any subject. In this version, there is enough information to recognize the person; viewers are allowed to fill in the rest.

Medium and small round brushes are good choices for this stage.

- Darker midtones suggest a worn plaid shirt and describe the shoes and hoe.

- Two linear strokes add suspenders.

- Layered strokes indicate the drape of the trousers.

- Small touches of pigment add definition to the facial features and clothing. White gouache is used to add highlights as needed.

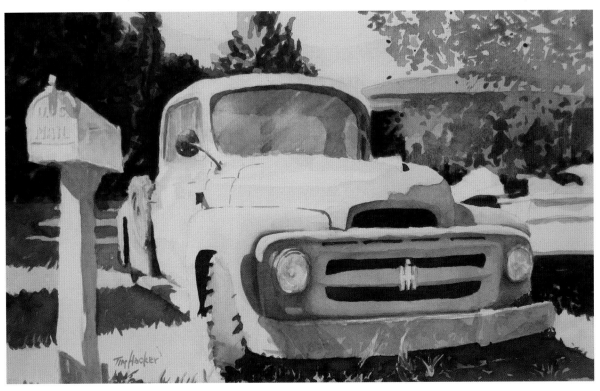

Tim Hacker, *Waiting for the Mail*, 22" × 30", watercolor on paper.
A simple record of light and shadow makes an arresting pattern. This everyday subject becomes remarkable when interpreted with an impressive pattern of values.

Interpreting Value Relationships

Values do more than capture a subject. We use them selectively to emphasize the most important features of a subject. At its simplest, this concept is used to focus the viewer's attention on what we see as the key areas within a scene.

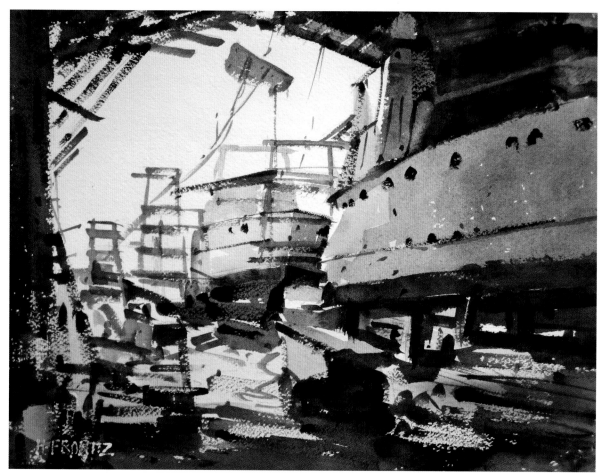

Harold Frontz, *The Boat Shed*, 9" × 12", watercolor on paper. The dark, dimly lit interior creates a tunnel effect, directing the eye to the light-filled boat yard and beyond.

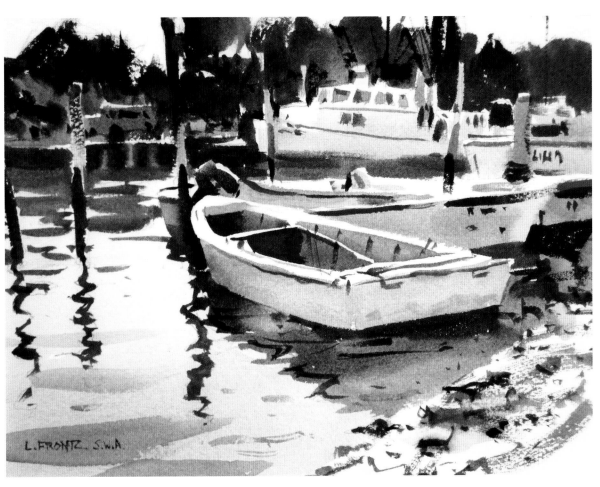

Leslie Frontz,
Quiet Morning, 8½" × 11½",
watercolor on paper.
In this watercolor, dark values
encircle the white boats,
accentuating the glittering
morning light on their sunlit
surfaces.

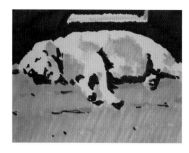

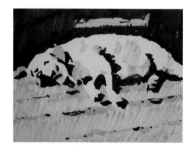

Thumbnails allow us to preview alternative versions of a subject with a minimum of time and effort. Each features a different distribution of values.

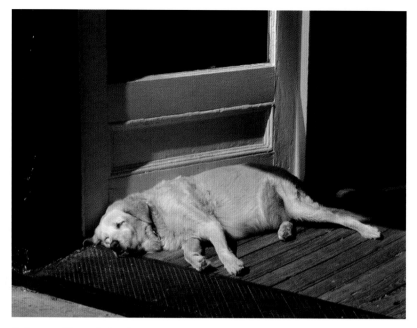

Reference Photo: A dog dozing in a sunny spot makes an appealing subject, but the values are not all they could be.

A dog dozing in a sunny spot makes an appealing subject. The darks boldly define the dog's head, back, legs, and belly. The porch is in light, but it falls a little short of being an irresistibly sunny spot. The door and dark shadows are a little overwhelming. We see the shortcomings in this subject, understand that there are many possible solutions, but need a quick and easy way to preview our options.

The Thumbnail Sketch

Thumbnails are small value studies. Their small size allows us to make different versions quickly.

The first thumbnail takes its cue from the reference photo: a dark background, a light dog, and midtone floorboards. The second provides a sunnier spot, but the dog is less important. In the third arrangement, the dog regains the spotlight, and there is a sufficiently sunny spot for its nap. Sometimes small changes make a big difference; this version has promise.

Painting from Dark to Light

Translating values onto paper is vitally important. Painting from light to dark is a sound beginning, but it has some drawbacks. Against white paper, pale washes will look much darker than they really are. We tend to inch toward the dark values. Starting with the darkest values eliminates this challenge.

DEMONSTRATION: Dog Days of Summer

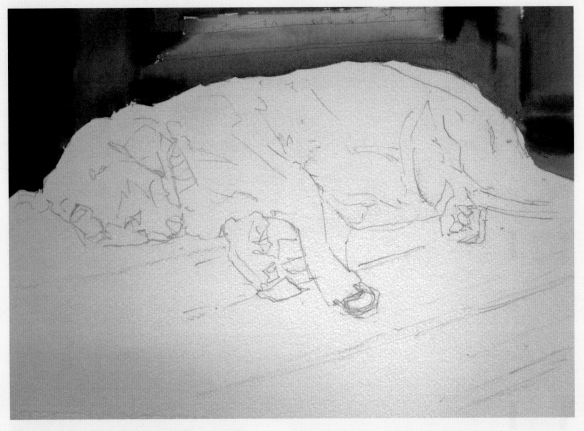

The strong light and dark pattern makes this subject noteworthy. Recording this relationship early in the painting process makes it easier to paint.

STAGE 1

A wet-against-wet wash on dry paper immediately captures the darkest values. Against the white paper, we can see the entire range of values with the first strokes of color. Visualizing how the remaining tones fit between them follows naturally.

A large flat easily handles these blocky shapes.

- At the far right and left, the shadows are mixes of alizarin crimson and ultramarine blue.

- The door features various mixes made from the reds, blues, and earth colors.

- While the wash is still damp, burnt umber is charged into the shadows.

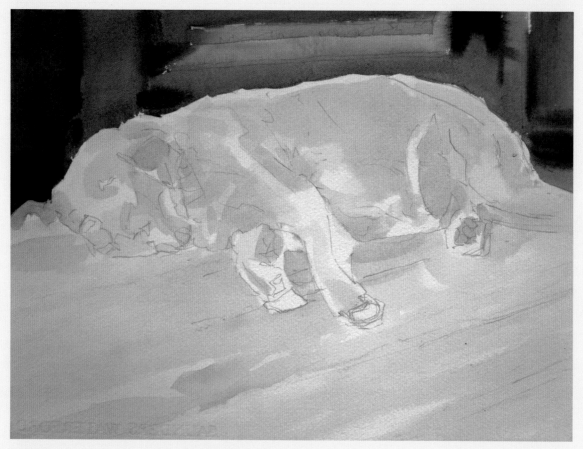

A patchwork of light values suggests the rounded volume of the sleeping dog. A broadly painted shape establishes a foundation for a sunny porch.

STAGE 2

Layered washes are used to establish the general form of the dog's head and body. Keeping the values within the light range maintains the integrity of the shape. The porch floor is less important and treated very simply.

A large round brush is used for the dog. Either a large flat or round can be used for the floorboards.

- Pale raw sienna is painted around the highlights on the dog's body and the floorboards.

- When this layer is dry, light washes of color add volume to the dog's body. These are pale versions of the pigments used in the shadows.

- Another layer of pale color gives subtle texture to the floorboards.

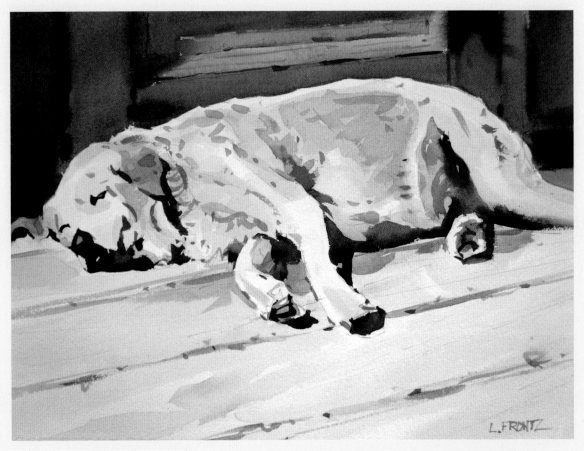

More brushwork adds definition to all areas of the watercolor. Bold shadows describe the dog's head, ears, legs, and belly.

STAGE 3

More brushwork brings the subject into focus. Spots and strokes of color define the dog's features and create the illusion of fur. Changing the size and direction of the brushstrokes suggests its texture.

A large round is used for the fur; a medium round is used for the dog's eyes and nose.

- Using the same pigments, layered shapes add form and texture to the dog's body.

- When the paint is dry, mixes of raw sienna, alizarin, burnt umber, and phthalo blue are added on and beneath the dog.

- A mix of raw sienna and burnt umber adds texture to the floorboards.

- Linear strokes complete the floorboards.

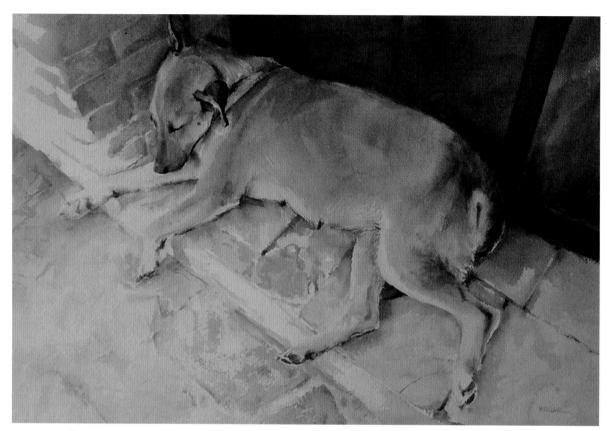

Jim McFarlane, *Let Sleeping Dogs Lie,* **14" × 21", watercolor on paper.**
This watercolor uses a full range of values, but the size and placement of the midtones create a subtler statement. The value contrasts are gentler, giving us a quiet, thoughtful account of a dog's life.

Summing Up

In a transparent medium, seeing a subject as a set of values is an essential skill. Beyond the technical issues, values unify the shapes that hold our paintings together. They give our subjects a sense of volume, ground them with shadows, and bathe them in light. In essence, values bring a subject to life.

Leslie Frontz, *Sunny Side of the Street*, 14" × 21", watercolor on paper.
The vibrant colors are noteworthy, but the pattern of light and dark supports and defines the subject.

MASTERING THE PROPERTIES OF COLOR

M aking decisions about color is part of our daily experience. We respond more positively to some colors than to others. We have definite ideas about which colors go well together and when or where to use them. Yet when it comes to putting color on paper, we question our ability to use what we know.

There are guidelines that help us apply these color skills to watercolor. They simply and logically explain how colors behave, how we might go about choosing pigments, mixing colors, and using paint to duplicate or interpret a subject.

This chapter covers all the basics of color. It explains why color theory does not always predict what pigments will do and how to overcome this hurdle. Demonstrations illustrate how interpreting the relationships among colors is the not-so-secret formula for success with color. The mastery of color is within reach of us all.

Leslie Frontz, *Seed 'n' Feed*, 8½" × 11½", watercolor on paper.
The fellows gathered around the truck are the focus of this painting. Making the truck bright red draws our eye to this area; the color choice serves a logical purpose.

Choosing Pigments

Learning something about pigments helps us make better choices among them. There are many available, and the list continues to grow. Gems, earth, minerals, seashells, plants, and chemical compounds are all sources of pigment.

All these sources share something in common. They are physical substances with known qualities. They reliably give paints their characteristic colors. This makes using pigments one of the more predictable aspects of painting.

Colors and Pigments

To learn how to mix pigments, artists traditionally turn to color theory. Among other things, it explains how colors behave when mixed together. This is of course something we want to know. What we must remember is that colors and pigments are not quite the same.

Color is the more fluid term. A color can be a large family of related hues, like the color red. It might instead describe a smaller family, like ruby or rose. Naming colors—also referred to as hues—lets us translate what we see into words, but it is not very exact. It is a practical method for conveying the appearance of things, but not a precise one. There is no color that we would all agree is the "true" red.

These pigments are all versions of the color red, but they look and perform differently. Each produces singular results when mixed with other pigments.

Color theory gives us only *general* principles for mixing paint. As with most general rules, there are exceptions. It still provides a good starting point: a solid base from which we can learn how to mix pigments.

Primary Colors

Yellow, red, and blue are primary colors. To use primaries in a painting, we must have them on our palette. They are versatile performers; we can mix an wide range of other colors from them. Mixing two primaries makes a secondary color: an orange, purple, or green.

These three colors are primary in the sense that they cannot be mixed from other hues.

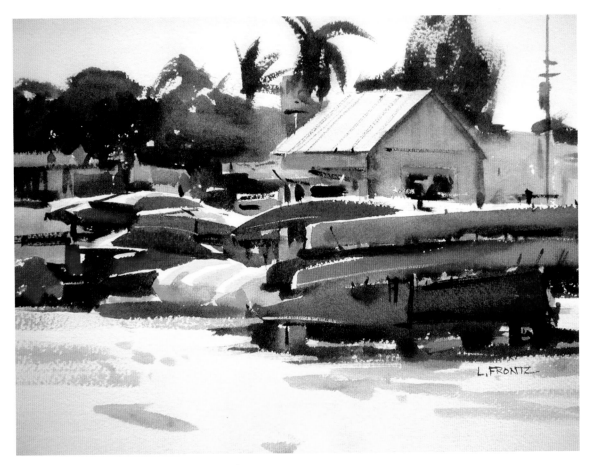

Leslie Frontz, *Boat Rentals*, 8½" × 11½", watercolor on paper.
Most of the colors in this subject are either primary pigments or mixed from primaries.

Leslie Frontz, *Water's Edge*,
8½″ x 11″, watercolor on paper.
This version of the subject was
possible because there were
yellows, reds, and blues on
the palette.

Leslie Frontz, *Wine Country,* 6″ × 10″, watercolor on paper.
Primary colors are only "primary" on the palette. This interpretation of the Tuscan hills
relies almost exclusively on secondary colors mixed from the primaries.

Mixing Secondary Colors

Mixing two primaries makes a secondary oclor. The position of the secondaries on the color wheel explains how we mix them. Orange falls between yellow and red. Mixing yellow and red makes orange. Red and blue make purple, and blue and yellow make green. The color wheel indicates the general formulas for mixing the secondary colors.

In theory, the color wheel illustrates how to mix orange, purple, and green. In practice, it provides only guidelines. The color wheel tells us that mixing a yellow pigment and a blue pigment will produce a *version* of green. It may look like the green on the color wheel, or it may not. When painting, we are mixing real pigments, not hypothetical colors.

The Color Wheel
This color wheel is a simple illustration that visually charts the most basic formulas for mixing secondary colors.

This mix of yellow and blue looks nothing like the green on the color wheel.

To make the green on the color wheel, we must use specific primary pigments.

When mixing pigments, we generally have a particular result in mind. We want to mix a precise hue. To do this, we must be able to predict what will happen when we mix pigments together. Learning how to mix the secondary colors we see on the color wheel is a good beginning. To do this, we will use all *six* of our primary pigments.

These formulas are worth remembering, but mixing pigments is something we learn by *doing.* Each secondary on the color wheel is the result of mixing two primary pigments:

> **Cadmium yellow + cadmium red = the color wheel orange.**
>
> **Alizarin crimson + ultramarine blue = the color wheel purple.**
>
> **Cadmium lemon + phthalo blue = the color wheel green.**

Mixing Tertiary Colors

The six pigments used to mix the secondary colors will make six vibrant in-between hues, called tertiaries. The same pair used to make orange will also produce yellow-orange and red-orange. Colors like these are essentially variations of the secondaries: yellow-green, yellow-orange, red-orange, red-purple, blue-purple, and blue-green.

These six hues are the so-called tertiary colors.

We mix the two primary pigments until the tertiary color looks right. More yellow and less red make yellow-orange. More red and less yellow make red-orange. The same combinations of pigments are used to mix both the secondary and tertiary colors:

> **More cadmium lemon + less phthalo blue = yellow-green.**
>
> **More cadmium yellow + less cadmium red = yellow-orange.**
>
> **Less cadmium yellow + more cadmium red = red-orange.**
>
> **More alizarin crimson + less ultramarine blue = red-purple.**
>
> **Less alizarin crimson + more ultramarine blue = blue-purple.**
>
> **Less cadmium lemon + more phthalo blue = blue-green.**

When we use a small number of pigments, it is much easier to recall the formulas for different colors. There are relatively few combinations to remember, and we use them repeatedly.

OPPOSITE: Roger Parent,
Temple of the Nuns, **29" × 21",**
watercolor on paper.
This watercolor is organized around variations of tertiary colors, primarily red-orange and blue-green.

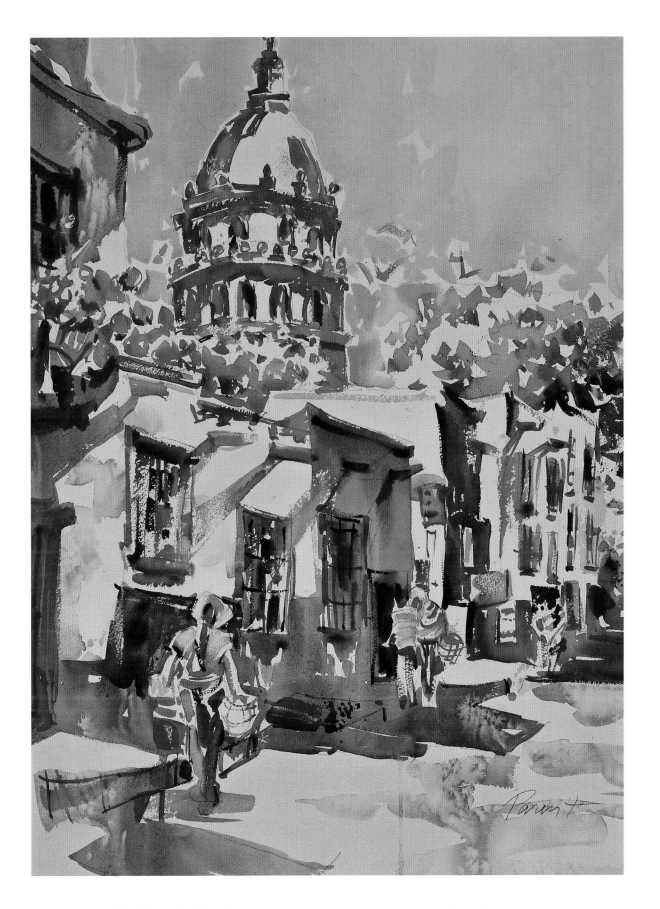

The Double Triad Palette

The next step is to bridge the crucial gap between theory and practice. Color theory suggests that we mix these hues from *three colors*: yellow, red, and blue. In practice, it is necessary to use *six pigments*. It takes the right combinations of primary pigments to paint a color wheel, but the color wheel does not predict how pigments will behave.

The double triad palette uses two versions of each primary color. Neither version is a perfectly balanced primary. One red contains too much yellow to be a true red. The other red on our palette contains too much blue. We might say that each is biased in the opposite direction: toward a different primary.

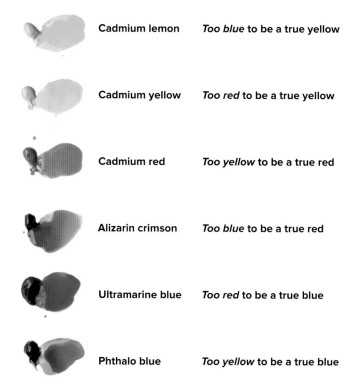

Cadmium lemon *Too blue* to be a true yellow

Cadmium yellow *Too red* to be a true yellow

Cadmium red *Too yellow* to be a true red

Alizarin crimson *Too blue* to be a true red

Ultramarine blue *Too red* to be a true blue

Phthalo blue *Too yellow* to be a true blue

However, we can make these primaries behave perfectly when we understand their color flaws. Grouping pigments in the same color family on the palette makes it easier to spot their biases as well as to take advantage of them.

These six pigments—two of each primary—produce all the bright secondary and tertiary colors. We can also use them to mix a wide range of more subtle colors.

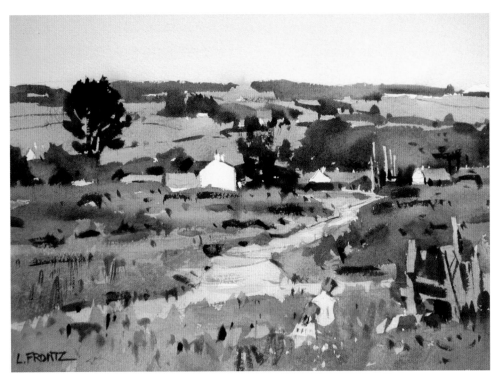

Leslie Frontz, *Hills of Antrim*, 8½" × 11", watercolor on paper.
Subjects like this one provide a challenging opportunity to hone our color skills.
This watercolor is dominated by many variations of green.

The Mixing Wheel

The mixing wheel illustrates how to create all the bright secondary and tertiary colors from the six primaries on our palette. It demonstrates how color theory is actually put into practice. There are three pairs of primaries. *The bright secondary colors are mixed from two adjacent but different primary colors.*

Learning by doing—painting the color mixes—will double the value of this chapter. The yellow closer to the red—cadmium yellow—and the red closer to the yellow—cadmium red—will make a clear, bright orange. Similarly, the lemon yellow mixes with the phthalo blue to make a vivid green. This is by no means a new idea: versions of this palette have been used by successful artists for many decades.

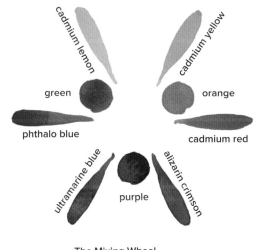

The Mixing Wheel
To learn how artists use pigment, we refer to a wheel that includes two complete sets of primaries.

Mixing Bright and Dull Colors

So far, we learned only how to mix bright secondary and tertiary colors. By using a double triad palette, we can mix brighter and duller versions of any color and predict which pigments will give these results.

Alizarin crimson is almost a reddish violet. Ultramarine blue is slightly purple. We might also note that these two primary pigments are neighbors on the mixing wheel. Neither is perfect, but each leans toward the other. There are only two primary *colors* in the mix: red and blue. Together they make a bright purple.

Pigment formula: alizarin crimson + ultramarine blue

Color formula: (red + blue) + (blue + red)

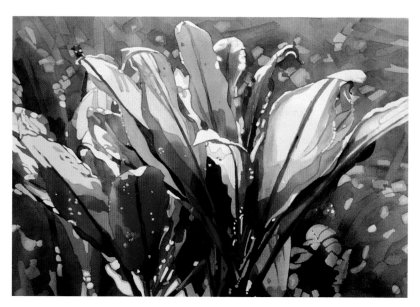

Jean H. Grastorf, *Back Light Canna*, 22" × 28", watercolor on paper.
This subject is loaded with color. The bright foliage stands out against more subtle hues.

There are other red and blue pairs on a double triad palette. Cadmium red and phthalo blue are an interesting duo. Clearly, these are not neighbors on the mixing wheel. In fact, they are not even close; there are two other primary pigments between them: alizarin crimson and ultramarine blue. This time, neither primary pigment leans toward its partner. They both lean toward yellow, the third primary color.

Pigment formula: cadmium red + phthalo blue

Color formula: (red + yellow) + (blue + yellow)

Even though we have not added a third primary *pigment*, we have added a double dose of the third primary *color*. Both the red and the blue contain a measure of yellow. When we mix three primaries, the result is a duller color.

Judi Betts, *Rendezvous*, 22" × 30", watercolor on paper.
The artist added bits of bright jewel-like color among the larger, more muted shapes to carry the viewer's eye throughout the painting.

There are two more red and blue mixes on our palette: alizarin crimson and phthalo blue, and cadmium red and ultramarine blue. Either pair should give us a recognizable purple. Neither will be extremely bright or dull; both will fall somewhere in between. We can make this prediction with confidence. Only one primary pigment separates each pair. Yellow, the third primary color, appears only once in each formula.

These two purples are much as we would expect: in between the brightest and dullest mix.

Pigment formula: alizarin crimson + phthalo blue

Color formula: (red + blue) + (blue + yellow)

Pigment formula: cadmium red + ultramarine blue

Color formula: (red + yellow) + (blue + red)

Tertiary colors are mixed in exactly the same way, using the same pigment formulas. The only thing that changes is the proportion of the pigments in the mix. A small number of carefully chosen pigments produces a wide range of colors.

With this palette, we can easily identify the pigments that will give us the colors we want. These two yellows, two reds, and two blues make bright colors, dull colors, and those that fall in between.

There is no reason to exclude our favorite pigments from the palette. We could replace alizarin crimson with any bluish red. Phthalo blue/red shade is similar to ultramarine blue. There are many alternatives for the primaries used here.

With a small number of primaries doing most of the work, there is room on the palette for other pigments we enjoy using.

OPPOSITE: Leslie Frontz, *Courtyard, Assisi*, 11" × 8½", watercolor on paper. This watercolor is painted almost entirely with muted colors. We are mistaken when we think of these as being dull and dreary. They are both rich and subtle.

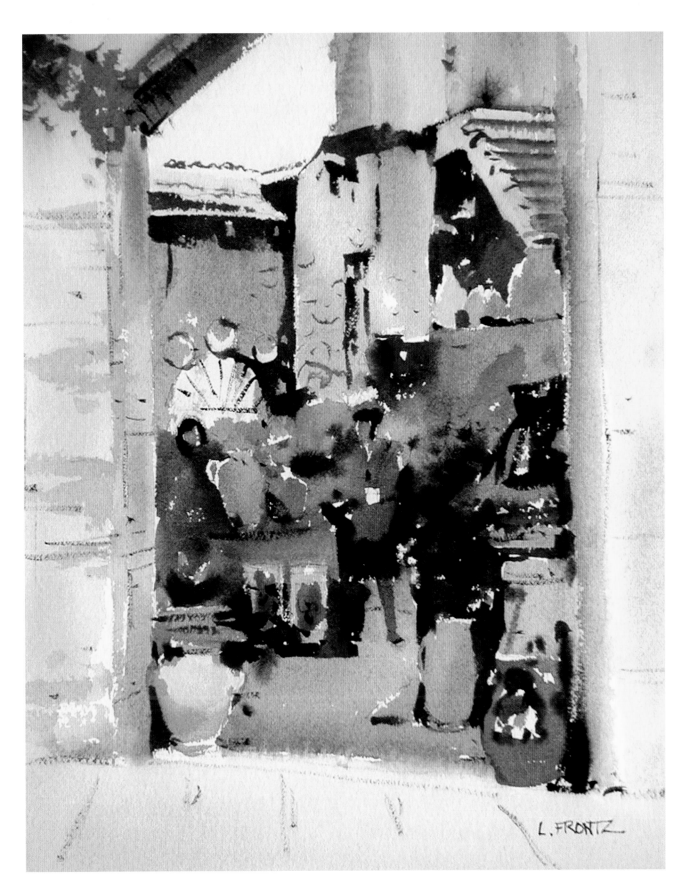

L. FRONTZ

Mixing Light and Dark Colors

With dark pigments, we can obtain a full range of values by adding water. Lighter pigments present some challenges. To deepen their value, we must mix them with darker pigments.

The result is a change in color as well as value. The color of the mix will fall between the two. We can lessen this effect by adding a darker pigment in the same color family.

At some point, everyone tries to darken yellow with black. The result is a dull green.

There are no dark primary yellows. In fact, we might struggle to visualize such a thing. Mixed with yellow, raw sienna gives us a broader value range of golden hues. We can complete the value range by mixing yellow with burnt umber.

Our palette is based on primaries because they allow us to make a wide array of colors from a few pigments. The earth colors also contribute some interesting mixes. Our personal favorites on the palette also expand our mixing options. There is a lot of enjoyment in discovering what our pigments will do.

When we look at a subject, we see light against dark, bright against dull, and one hue against another. These are the relationships we attempt to capture in our watercolors.

Adding raw sienna and burnt umber to a yellow pigment produces colors that resemble what we may see as dark yellow.

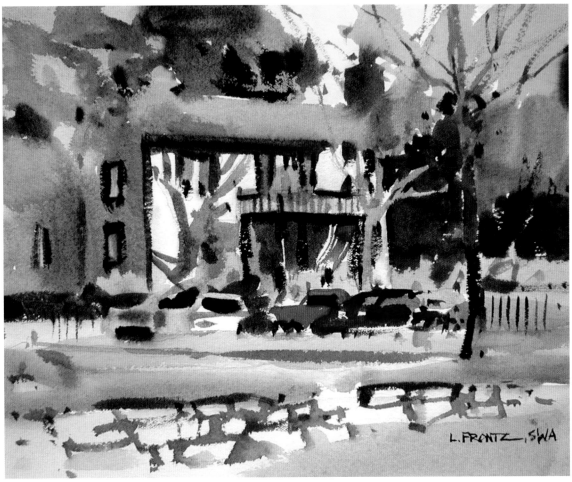

Leslie Frontz, *Piedmont Autumn*, 9" × 13", watercolor on paper.
The house and nearby objects features the lightest, darkest, and brightest colors. There is no doubt about where we are supposed to look.

The Principles of Color

We respond to color contrasts. The impact of any color is influenced by the hues surrounding it. The same is true in watercolor.

There are three guiding principles that take much of the guesswork out of using color. All three are linked by the premise that we see colors in relation to one another.

Color Principle 1

CONTRASTING COLORS

When colors are similar to their neighbors, they hum a gentle harmony. Colors that are less like their neighbors sing out. A light blue sky seems relatively quiet. Add orange clouds reflecting warm sunlight, and the sky calls for attention.

Orange and blue have a special relationship. These two colors are opposite one another on the color wheel. They are as unlike as they can be, so they are described among painters as being complements, meaning balancing counterparts. Red and green make another complementary pair, as do yellow and purple. Complementaries form a pair with maximum color contrast.

Cameras often lose these color contrasts. The resulting photos may appear less exciting than the subjects that we wanted to paint. On location, the sky was outstanding. The sun was low on the horizon, bathing the undersides of the clouds with a warm, golden glow. The contrasts between the warm sunlight and cooler shadows made an arresting scene.

Reference Photo: In this photo reference, the camera failed to record the golden glow from the sun. The diminished color contrast reduces the impact of the subject.

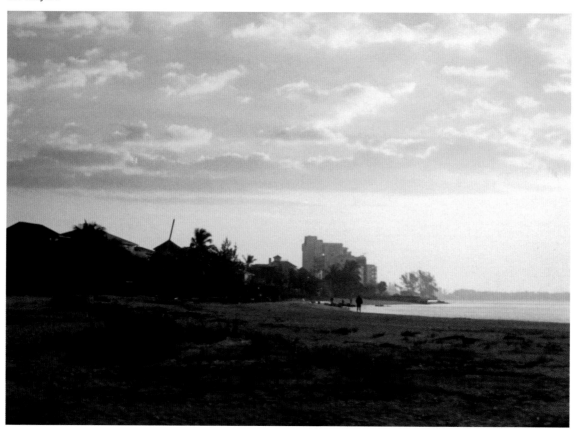

DEMONSTRATION: Rooms with a View

Once we understand the relationships among colors, we are in a position to use them creatively. Contrasting colors will make the view more dramatic.

STAGE 1

In the photo, dull blues dominate the scene; the complementary color that inspired the photo is missing. Returning the warm glow adds life to the scene. This stage completes two shapes: the upper sky and the beach.

A large round is used to paint both shapes.

- In the upper sky, ultramarine blue is painted around an irregular line of small light clouds.

- With a mix of ultramarine and phthalo blue, more white clouds are created immediately below.

- The band of warm light on the underside of the cloud bank is raw sienna and alizarin crimson.

- The beach features muted blues and purples. While this passage is damp, clear water is used to soften its upper left edge.

The varied edge of the roofline helps keep our attention focused on the sky. It also identifies the location and adds character to the subject.

STAGE 2

When the beach is dry, a wet-against-wet wash captures the intricate roofline and subtle interior of a shadow shape: the condos and trees. On the beach, grassy clumps add interest and depth.

Round brushes are good choices for this stage.

- The distant view at the far right features a muted orange and yellow-green; adding blue pigment creates shadows.

- The beach houses feature darker mixes of the same subtle colors used for the sand. A sunlit patch is muted orange. The foliage below is burnt umber and phthalo blue.

- The grasses are dull, warm greens that diminish in size as they recede into the distance.

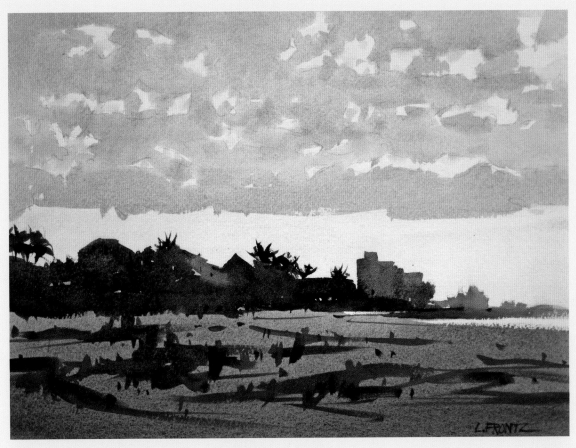

To create the illusion of glowing light, a pale, golden glaze is painted over the entire sky.

STAGE 3

A glaze completes this watercolor. This is an even wash of color painted over very dry pigment. The top of the watercolor must be raised so that the paint will run downward. A big puddle of paint is prepared before beginning a glaze.

Glazes are applied with a large brush; a flat is the traditional choice.

- A wide stroke of pale raw sienna is drawn gently across the top of the paper. A bead of paint will form along its bottom edge.

- The next stroke slightly overlaps the first, picking up the bead of paint.

- The last stroke gently overlaps the edge of the roofline.

- When the glaze is dry, the trees along the roofline are added with a medium or small round.

MORE TIPS FOR GLAZES

1. Make certain any pigment that the glaze will cover is thoroughly dry.

2. Fill a small container with more than enough diluted pigment to cover the entire area.

3. Remember to tilt the painting board to encourage the paint to bead.

4. Resist the urge to "repair" a glaze; this often disturbs the underlying pigment.

5. Apply a glaze on dry, unpainted paper when a solid, even background color is desired. This creates a flat wash.

6. Dilute the pigment with a little more water before applying each successive brushstroke. The bottom of the paper will be lighter than the top. This is called a graded wash.

Leslie Frontz,
Beach House, 7½" × 10½",
watercolor on paper.
Bright colors and white
shapes make even small
figures stand out.

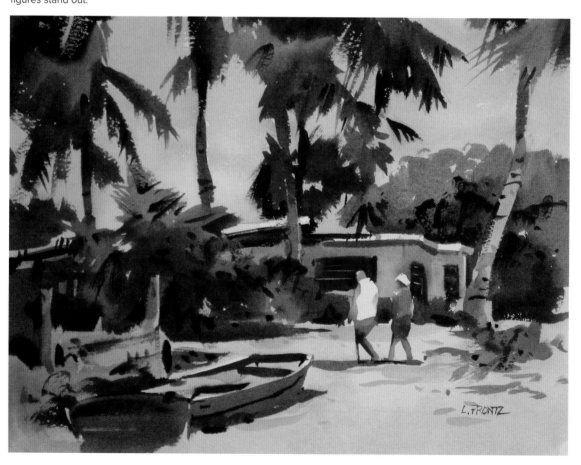

Color Principle 2

CONTRASTING LIGHT AND DARK COLORS

A lighter color makes its neighbors seem darker, while a darker one makes adjacent hues look lighter. Raw sienna looks dark next to cadmium lemon but light next to phthalo blue.

Every pigment has a value. So does every color we mix from them. This is now familiar territory. So is the fact that contrasts in value and color are powerful tools for the watercolorist.

The challenge is that we are so often trying to match a color that we ignore its value. At the end of the day, our painting fails to capture the subject.

Reference Photo: The light and dark colors in this subject work together very effectively. The pale hues of the water and beach set off the backlit figures.

In the scene, color plays an important role. The red chair is especially striking. We might miss how dark it is and how much impact this has on the subject. All the colors read clearly against the pale sand. Against a darker background, they would not be nearly so striking.

DEMONSTRATION: Watching the Waves

Painting the beach a pale beige seems like a reasonable solution, but might fail to capture the light-filled quality of the sand. Mixing colors on wet paper provides the solution.

STAGE 1

Exaggerating the colors in this subject will reinforce just how important their values really are. We can transform the beach from lackluster to luminous without compromising the subject.

In this wet-into-wet wash, the colors are mixed on the paper. A large flat brush allows us ample time to finish it.

- Below the waterline, a watery wash of cadmium yellow is brushed across the wet paper.

- Pale cadmium red is introduced in the same area with a feather-light touch.

- Alizarin crimson and Indian red are gently introduced into the wash. As long as the paper remains wet, more pigment can be added to improve the color.

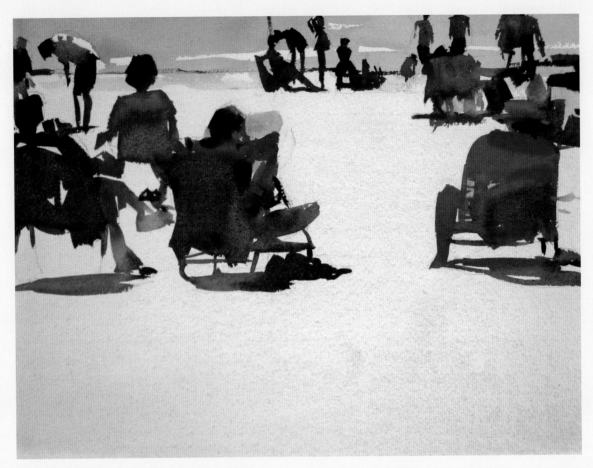

Once the wash is dry, the darker water and figures are layered over it: a classic watercolor technique.

STAGE 2

Our goal in this stage is to preserve both the color and value relationships rather than to copy exact hues. In this version, the colors are more varied and pronounced.

Large and medium round brushes are used to paint this wet-against-wet passage.

- In the green water, white paper suggests surf.

- Primary blues are used for chairs, clothing, and shadows at the left. Skin tones are Indian red.

- The same colors indicate the distant figures. Yellow, rose, red, and purple accent the figures and beach gear.

- All six primaries are used for the figure in the red chair, along with the earth colors and cobalt turquoise.

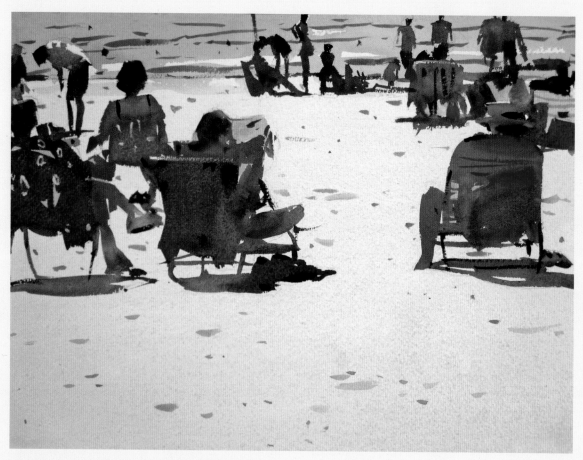

The final strokes of color bring everything into focus. Waves in the water and dimples in the sand explain the setting.

STAGE 3

A variety of strokes give definition to the chairs, clothing, water, and beach. This version uses details judiciously: a personal choice.

Both watercolor and gouache are used in this stage. The brushwork is applied with a medium round.

- Horizontal lines create a pattern of waves.

- Short strokes of warm mixes suggest dimples in the sand.

- White gouache is used to add pattern and highlights to various objects.

- Darker lines suggest plastic webbing, the legs of chairs, and details on clothing.

Color Principle 3

CONTRASTING BRIGHT AND DULL COLORS

A muted color makes its neighbors appear brighter; a bright color makes its neighbors look duller. A color that seems bright in one context may appear dull in another. Alizarin crimson looks more vibrant next to Indian red than when placed against cadmium red.

Intensity is the term typically used to describe a color's level of brightness or dullness. Like other properties of color, this one describes relationships among different hues. It is how we place color against color that counts.

This means that we can influence the intensity of any color by altering the colors around it. Surrounding a hue with more muted colors will make it appear brighter. The mixing wheel makes it possible to create a wide range of neutral colors, and the earth colors on our palette supplement these subtler hues.

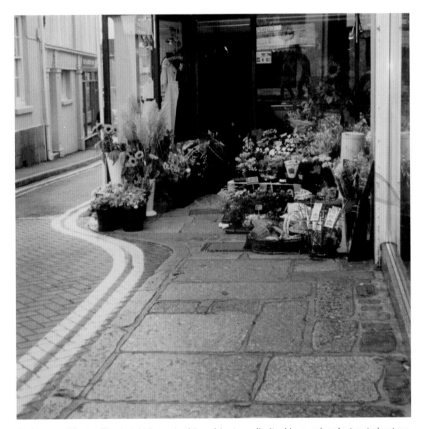

Reference Photo: The bright hues in this subject are limited in number but not short on vitality. The vivid flowers pop out against neutral hues in the rest of the scene.

DEMONSTRATION: Flower Girl

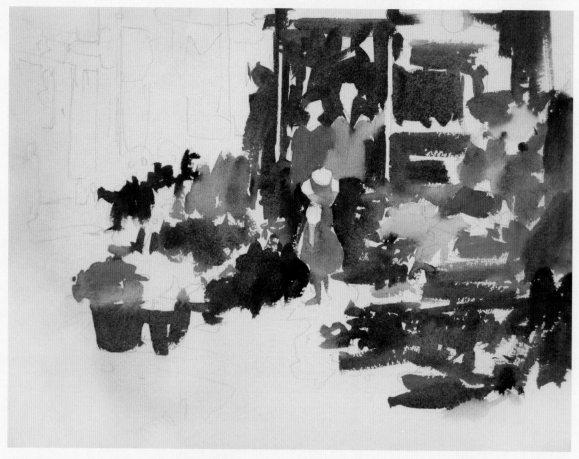

At the heart of this subject are intense areas of color.
The more muted colors exaggerate their importance.

STAGE 1

A gray day with drizzly mist focuses attention on the
vibrant blossoms. Adding and brightening colors at
the doorway will boost the effect.

In this stage, we adapt our washes to suit the
subject. Round brushes are used to begin this work.

- The girl's dress is phthalo blue; the hatband on
 her bonnet is pure cadmium red. To maintain
 focus on the child, the other figures are given
 more muted apparel.

- The wet-against-wet technique is used to create
 the pattern of dark shapes around the shop
 entrance. The colors are primarily subtle purples
 and greens. Dark blue pots are added at the left.

- When dry, strokes of red, orange, and pink are
 used to suggest blossoms.

Watercolor washes are versatile; they can be modified to fit most subjects. This stage features three wash techniques.

STAGE 2

Direct painting, glazes and washes on dry paper, layering, and some wet-into-wet painting are all used to develop the subject. The paper must be completely dry before beginning this stage.

Each technique is applied in limited areas. The pigment is delivered using a light touch and a large brush.

- Any unpainted areas at the bottom left are dampened with clean water. Pale warm and cool colors are added as desired.

- Muted purples, oranges, and blues are gently glazed over the front of the shop.

- When the paper is dry, a pale wet-against-wet wash is used to suggest the misty side street and pavement.

- Bright yellows are introduced among the flowers, and the figures are completed as desired. Mixes of burnt umber and ultramarine suggest the wet pavement.

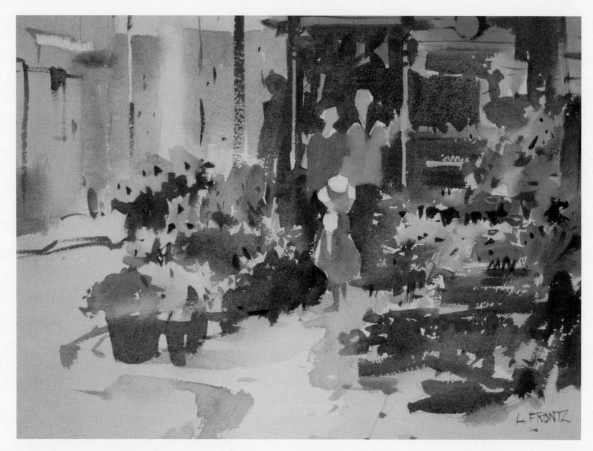

The finishing strokes add definition to the buildings, pavement, and the floral display.

STAGE 3

The side street, pavement and flowers are given more attention. The muted colors are adjusted to heighten the appeal of the brighter hues.

The paint must be dry before adding more pigment. A medium round brush is useful for adding these last touches of color.

- Another wash of muted warm and cool colors makes the street at the left look wetter.

- Small spots and lines add definition to the flowers and shop.

- Curved lines suggest the curb at the bottom left.

- Loosely painted vertical lines complete the buildings at the upper left; horizontals suggest the edge of the pavement.

Summing Up

Color is a much more straightforward subject than we might imagine. Each of the three color principles involves contrasts: differences in color, value, or intensity. We use these qualities to emphasize the most important aspects of a subject and subdue those that play a supporting role.

There is no mystery to mixing colors and no secret pigments that guarantee success. With all the information available about color theory, it comes down to choosing and using a palette that allows us to interpret these color relationships.

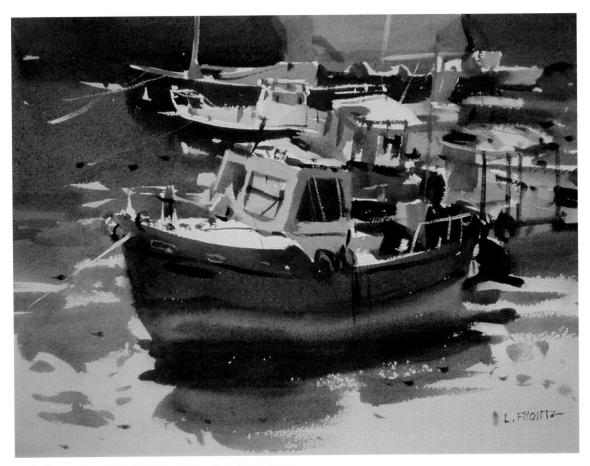

Leslie Frontz, *Cornish Light*, 8½" × 11½", watercolor on paper.
What draws the eye to this scene is the relationship between the orange and blue notes in the fishing boat. The contrast stimulates our interest.

Chapter 5

UNDERSTANDING THE FUNDAMENTALS OF LINE

I n watercolor, a line is simply the trail left by a brush. Lines do more than define objects. They organize our watercolors and convey our attitude toward a subject. We can use lines to suggest the essence of a scene without having to say too much about it.

To make the most of lines, we explore more versatile ways to use our brushes. It is possible to maintain control over a brush without applying pigment in a controlled way. There is a big difference between the two.

Brushwork requires greater freedom of movement than is typically allowed by our standard "pen-and-pencil" grip, which can be stilted and awkward.

Holding the Brush

There is no right way to hold a brush, but freedom of movement is essential. We should be able to press and lift the brush, rotate the wrist, and then sweep the brush across the paper to make a broad gesture. The following method allows for all this.

The Open Grip

1. Pick up a clean, large, round brush as if it were a pencil. Guide the brush around the paper. Making small and large gestures with the brush allows us to assess our range of movement.

2. With the opposite hand, gently tug the brush downward. The thumb should rest where the handle narrows.

3. Slide the thumb farther up the handle. This shift in position will pull the fingers and brush gently downward, bringing the brush into a more vertical position.

4. Move the brush freely over the paper. Use the shoulder, arm, and wrist to change pressure and direction. To deliver a stroke at an angle, we change the position of the wrist or hand; our hold on the brush remains the same.

Right-Handed Left-Handed

1

2

3

4

Right-Handed Left-Handed

 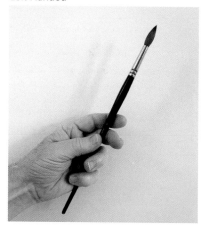

1

2

The Handshake Grip

Some watercolorists prefer painting with their paper in an upright position. They consider the drips and runs that result to be a natural part of the painting process. The arm is often lifted up and away from the body to deliver a brushstroke.

When painting with the paper upright, a handshake grip may be more useful. When the paper is flat, this grip makes it easier to deliver long strokes down or across the paper with assurance.

1. With the palm upward, reach for the brush as if about to shake hands. Fold the fingers comfortably around the handle.

2. Flipping the hand over so the palm faces down provides an overhand variation that is useful for delivering long, horizontal brushstrokes.

Stabilizing the Hand

Our dexterity with a brush is variable. Not all movements come naturally to us. Nor are we equally coordinated every day; there are times when a little support seems necessary. A mahl stick steadies a brushstroke by supporting our hand above the surface of the paper. It enables us to take chances without much risk. It is an intermediate solution: not free and loose, but not as rigid as the pen-and-pencil grip.

MAKING AND USING A MAHL STICK

Mahl sticks come in many forms, but all are essentially wrist rests. They were originally made from bamboo or cane, and the tip was a scrap of leather filled with rags. Today, a dowel rod and cork make a handy and inexpensive version. A drill and white glue are the only tools needed for this project:

1. Cut the dowel to the desired length. The version shown here uses a 17-inch length of dowel that is ⁵⁄₁₆ inch in diameter. Keep in mind that a little length is lost when the cork is added.

2. Drill a hole the diameter of the dowel rod in the small end of the cork. The cork shown here is 1⅛ inches.

3. Apply white glue on the end of the dowel and insert it into the cork.

4. Wipe off any excess glue. Let the glue dry thoroughly before use.

We can anchor the cork over the edge of the painting board or balance it on the board. The cork may also rest on a watercolor in progress, but this is risky. Both the painting and cork must be perfectly clean and dry.

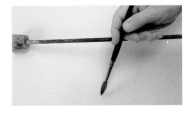

A right-handed watercolorist stabilizes the mahl stick with the left hand and paints with the right.

A left-handed watercolorist stabilizes the mahl stick with the right hand and paints with the left.

Developing a Personal Calligraphy

When we look at a watercolor, we sense the movement of the artist's hand. If the application of paint looks skilled and assured, we applaud the bravado behind it. Brushwork reveals the mastery of the artist. What we often fail to recognize is that the appearance of a watercolor can be misleading. "Loose" brushstrokes are well-managed. "Tight" work should be the result of expertise rather than rigid control.

This is an important distinction, as many watercolorist find the idea of letting loose with a big, juicy stroke of pigment daunting. Our distinctive calligraphy is due in large part to our choices about how to hold the brush and how freely to move our hand and arm when delivering paint to the paper. The fact is, accomplished brushwork of any kind comes with practice. Learning to use a brush with skill is important.

Brushwork in watercolor develops much like handwriting. Once the basic movements have been mastered, our watercolors begin to develop a more personal character. Some artists choose to emphasize a measured, deliberate quality. Others prefer a more lively approach.

A loose approach to painting lines is not unlike traditional ink painting; the marks themselves can be expressive.

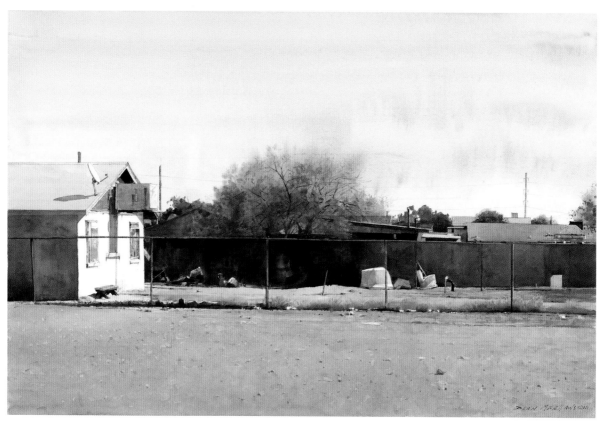

Dean Mitchell,
Reservation Wall, 20" × 30",
watercolor on paper.
The contours in this subject
are carefully rendered but
never overworked; the effect
is still and timeless.

The Functions of Line

Lines are typically understood as a way to convey very specific visual information about a subject. From long habit, we see lines as a way to draw around objects and bring details into focus.

As viewers, we actively look for these lines and pay attention to their properties. As artists, we naturally take advantage of this inclination. All the same, lines do much more than explain the appearance of objects.

Lines help us express our own ideas about a subject. They can also provide structure: an orderly way for viewers to interpret a subject. Lines have direction, so they point the way around and through a subject. Exploring their untapped potential offers an exciting journey for the watercolorist.

Adding Character

A single brush produces lines with many different qualities: thick or thin, bold or delicate. A brush can be pulled or dragged across the paper. We might plop or flop it. Lines are a record of our movement, and the results are significant. They express character.

Lines have an emotional language all their own. A thick line feels slower and heavier. A wavy line has a gentler feeling than a jagged one.

The fun is that there are no rules; this is art. We emphasize the features of a subject that are of most interest to us, and we do it our own way.

Paul Tooley, *Still Life with Tulips*, 15" × 22", watercolor on paper.
The fluid nature of watercolor is clearly evident in this still life. The brushstrokes look wet and flowing, as fresh as the medium itself.

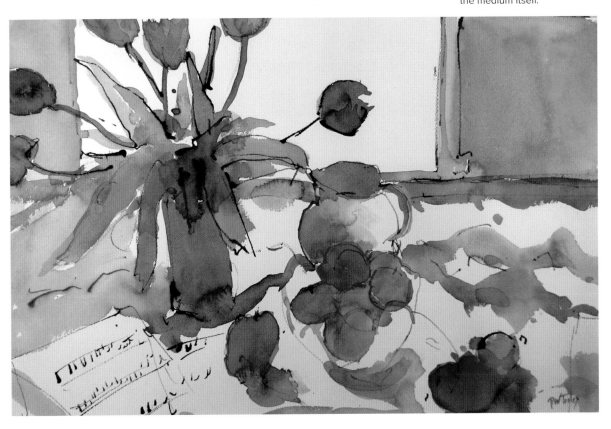

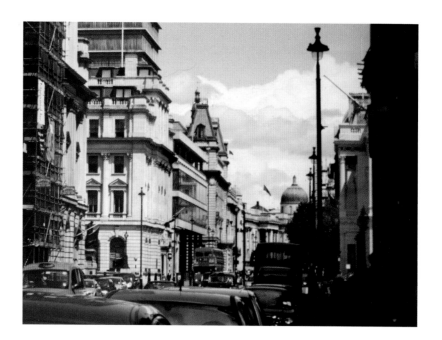

Reference Photo: Cast shadows create lines that sharply define the architectural features of this London thoroughfare.

Both studies interpret the same subject, but the pigment was applied more and less freely. Our use of brushes influences the look and feel of our watercolors.

DEMONSTRATION: A Rare Day in June

A single wash establishes the pale sky, sunlit buildings, and shadows along the street.

STAGE 1

This sunny street scene may look like a complex subject, but it is simply a network of lines over very basic shapes: a broad light area and small dark one.

A wash on dry paper is used to establish this relationship: a light sky and buildings and dark shadows along the street. A large flat brush distributes the paint quickly.

- The upper sky is a light blue mix, and the clouds are negative shapes. Their edges can be softened with clear water.

- In the lower sky, pale alizarin crimson is added to the mix.

- Raw sienna is used for the sunlit buildings. Other pigments are added wet-into-wet, hinting at some of the important architectural features.

- Cooler, slightly darker colors indicate the position of vehicles, foliage, and architecture at the right.

The shadows at street level form a dark band that climbs diagonally upward at the right.

STAGE 2

When the first stage is dry, a wet-against-wet wash suggests shadowy traffic and architecture along a tree-lined street.

This passage is painted with a large round.

- Mixes of earth colors are used to paint the darker passages at the top of the building.

- Phthalo green and burnt umber suggest the foliage.

- The rest of our effort is directed at capturing shapes that loosely represent the windshields and windows of the passing cars.

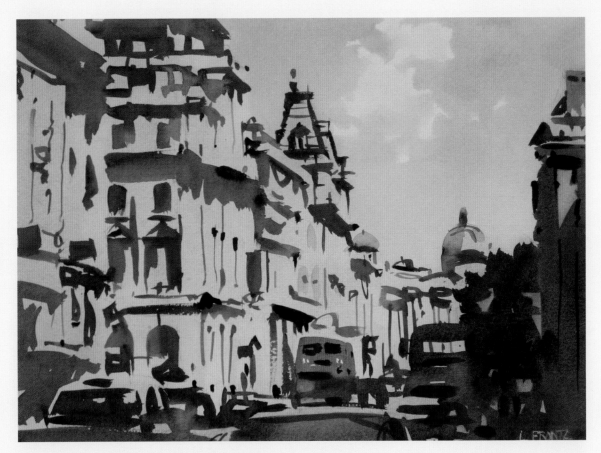

Lines identify the shadows cast by the many decorative features on the architecture. The lines vary: short and long, thick and thin.

STAGE 3

When the first stage is dry, the pattern of connected lines is layered over the wash. This passage identifies many objects, but the pigment is applied in a spirited way. We are as aware of the lines as much as the scene they reveal.

Large and medium round brushes are used throughout this stage.

- At the left, a large round is used to suggest the bolder architectural features.

- A medium brush carries the pigment into the rooftops and domes toward the right.

- The network of lines and shapes is carried down the paper until it connects with the shadows below.

- When the lines are dry, the small shapes receive our attention.

**Wilmer Anderson, *Apple Rain*,
21" × 29", watercolor on paper.**
The scattered figures and
apples are presented across
a pattern of broad, horizontal
contours that both support
and defy logic.

Providing Structure

There are lines in every subject. The first spot of color placed on the paper features a line of sorts. It forms an edge: simply the perimeter or contour of the spot. It also marks where some kind of visual change occurs.

We use these edges to bring even challenging subjects within our grasp. In this subject, the red awning is bordered by straight lines that make it easy to spot. There is also an "outside" shape that we are less likely to see. When we investigate this side of the contour, we take note of the cast shadows and dark entranceways that surround the awning. This dark shape extends in all directions, creating a structural grid that will support the subject.

Contour lines help artists present their subjects in a more systematic way. We might present objects against bands of gently undulating fields and clouds. We are essentially using scaffolding—patterns like grids, spirals, waves, or webs—to organize spots of color.

Reference Photo: The red awning is the main attraction, but a network of horizontal and vertical lines plays an important supporting role.

DEMONSTRATION: A Bird's Eye View

For this subject, we deliberately go outside the lines. This shape represents the bold passages that share edges with the red awning.

STAGE 1

Defining the edges around the awning forms a supporting framework: a bold pattern of broad horizontals and verticals with clearly defined edges. We can easily see how the subject will appear on the paper.

Mixes of blue and red pigments are applied wet-against-wet on dry paper. Using a large brush allows us to work quickly.

- The first stroke borders the lower edge of the awning. More brushwork completes the dark door and windows below.

- The shape is extended to the right of the awning, incorporating leafy shadows and another doorway.

- Shadows at the left and top edge of the awning are added. A broad stroke anchors the framework at the top edge.

- Adding the small darks at the top and left completes the framework.

The red awning introduces the brightest note in this scene. Once the stronger contrasts are identified, it is easier to judge the others.

STAGE 2

When the first stage is dry, other shapes are fitted into the framework. The result is an awning, buildings, and a fire escape.

The brushstrokes are delivered over broad areas using a light touch. Both large and medium brushes are used for these passages.

- The awning is bright red. The white lettering is left unpainted.

- At the left, a duller, paler red suggests the brick. When the pigment is barely damp, the sign is added with bright red.

- Muted colors are used for the smaller shapes around the fire escape and the building to the right. More shadows are added on the sidewalk.

- Color is added in the windows and doorways.

Having the key values and colors in sight makes it easier to find the right hue for the pavement. This shape is subordinate; its job is to set off the other hues.

STAGE 3

The pavement is much lighter than the shapes with which it shares edges. Its color is neutral but sunlit. To make this surface appear luminous, the pigments are mixed on the paper.

A large flat brush is used for the wash; medium and small brushes are used to complete the subject.

- On dry paper, pale sienna is washed over the pavement and around small light spots among the figures.

- Watery Indian red is brushed into random areas of the wash, followed by tints of phthalo blue.

- When the wash is dry, the figures and shadows are added. Smaller lines and spots define the sidewalk, architecture, and awning.

Jeff Good, *Moraine Lake*, 11" × 14", watercolor on paper. The robust horizontal shoreline is balanced by the more dynamic uprights and diagonals. The simple contrasts in direction express the nature of each area: placid water, growing trees, and steep slopes.

Emphasizing Direction

We attach many nuanced feelings to the direction of lines. Horizontals are stable, calm, and peaceful; they are literally and figuratively at rest. Verticals tend to ascend, a direction we associate with prominence. Diagonals are the most active lines. Meandering lines move across the paper in an informal, unhurried way. We use lines to encourage viewers to see the subject as we do.

Straight lines move us from one area to another without hesitation. Curved lines are less predictable. They move in different directions, and their movement seems random. These qualities influence our perception of a subject.

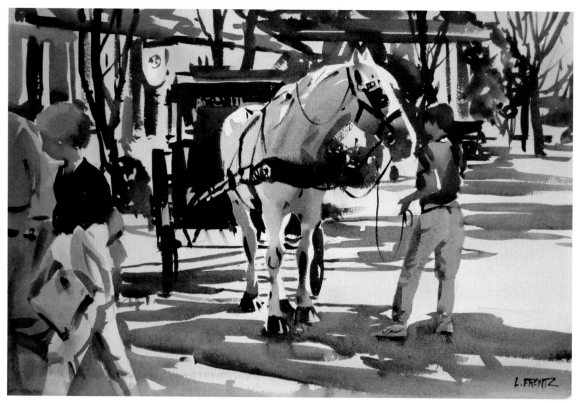

Leslie Frontz, *Curb Appeal*,
13¾" × 21", watercolor
on paper.
The lines in this subject amble
gently, much like the mild-
mannered horse in this subject.

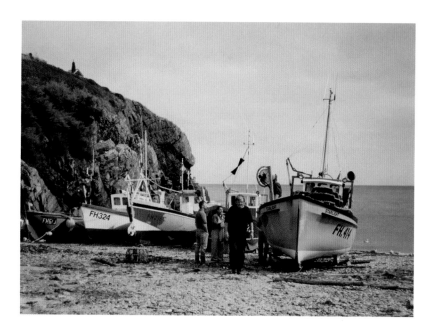

Reference Photo: This photo
has a horizontal emphasis,
a quality typical of a view
along a substantial shoreline.

Choosing a Format

Painted lines are not the only ones that affect how we see a subject. The format of a painting—the relationship of its height to its width—can also sway our judgment: it emphasizes a direction.

The wider composition draws the viewer's eye across the picture plane. It emphasizes the horizontal direction of the village, drawing more attention to the rows of buildings. The vertical format tends to draw the viewer's eye up through the picture plane. Our attention travels from the harbor to the village and sky. Direction generates interest selectively, accentuating some qualities of a subject more than others.

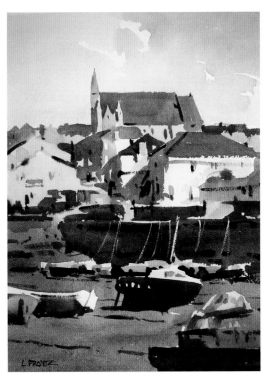

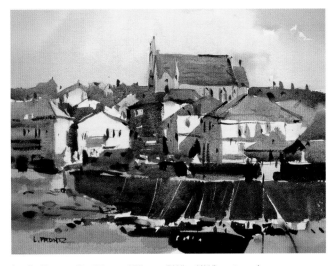

Leslie Frontz, *Porthleven Village*, 8½" × 11½", watercolor on paper. These two watercolors feature the same subject painted in the same manner, but their contrasting formats influence what we see.

Porthleven Harbor, **11½" × 8½", watercolor on paper.**

DEMONSTRATION: Fishing Stories

In terms of subject matter, this scene is about the fishermen and their boats. On another level, it is about the horizontals that characterize sea and shore.

STAGE 1

Layers of color are used to create a dominant horizontal emphasis, suggesting the character of the subject.

Large round and flat brushes are good choices for this first stage.

- Broad strokes of blue applied with a round brush create an irregular shape across the top of the paper.

- Two broad strokes of phthalo green suggest the lower sky; a darker mix is used for the water.

- Color is added to the boat hulls at the left.

- Mixes of raw sienna, burnt umber, and ultramarine are swept across the beach.

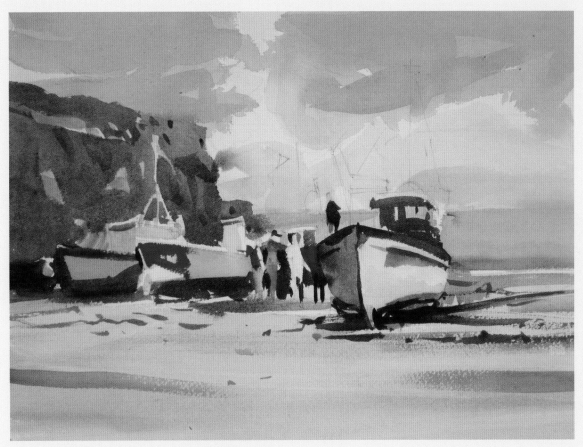

This stage calls more attention to the linear qualities of the subject. Lines embellish the sky, shape the headland, describe the boats and figures, and define the beach.

STAGE 2

When the paint is dry, another layer of shapes reinforces the horizontal direction. Their edges carry the eye across the paper, as does a repeating red and blue pattern.

Both large and medium brushes are used for this stage.

- A mix of burnt umber and ultramarine is used for the headland. A few small shapes in this area are left unpainted.

- Stronger pigments define the boats. The small figures repeat the red and blue colors.

- The large boat is left white; dark strokes above and below it emphasize the horizontal direction.

- When dry, more horizontal strokes are layered over the sky and headland.

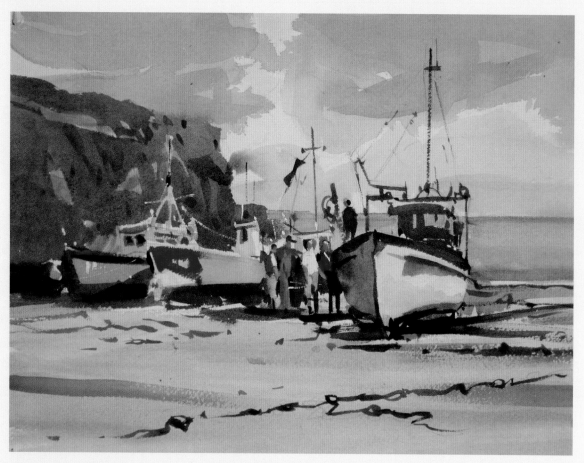

Less substantial lines define the boats, figures, and beach. These include contrasting verticals, which draw the eye to the area of greatest interest.

STAGE 3

Here the subject seems to appear like magic, although the most important work has already been done. Adding definition to the view obscures how the effect was achieved, but the horizontals still provide the necessary support for the subject.

Medium and small round brushes are good candidates for this job.

- The horizontals on the beach are boldly stated with dark pigment, again emphasizing direction.

- The masts, rigging, and lines are indicated with water or gouache.

- Small spots and lines complete the figures.

The Selective Eye

When we think of line as a way to add details, it can be difficult to decide when our watercolors are finished. We are uneasy about leaving anything unsaid. Approaching line as a way to add character, structure, and direction provides us with a clearer goal: suggesting the key qualities of a subject.

Not all areas of a subject need to be fully developed, so we can simply check for spots that seem relatively empty or lack the necessary interest. This can be accomplished by viewing our watercolor at a distance to see how well it works as a whole. Once our painting begins to successfully interpret the subject, we are closer to a successful conclusion than we might guess.

It is not necessary to describe every feature we see. The degree of finish depends on the importance of an object in our overall composition.

Joyce Cavanagh-Wood,
Sunny Glade, **9" × 5",**
watercolor on paper.
The subject of this watercolor is the forthright line of shadows, echoed again in the straight lines of the fence and the trees rimming the woods' edge.

A watercolor brush allows us to indicate objects concisely: a boatman, his boat, and a shoreline on which he might land.

Making Symbols

To create symbols that stand in for objects, we first let go of the idea that everything in our watercolor must be equally defined. The point is to include just enough information about an object to let it take its proper place in our watercolor.

The gestural quality of brushwork turns lines into effective symbols. We routinely see meaning in collections of lines; doodles, cartoons, and logos take advantage of this visual quirk. Creating symbols is literally simplicity itself.

To create symbols that stand in for objects, we first attend to silhouettes, avoiding any thought as to what the objects might be. The idea is to suggest a thing in the most direct way. We decide how much can be omitted, and then record the rest.

A figure at a distance might be suggested by nothing more than small gestures with a brush: a dot, a blot, and a line or two. Our viewers willingly fill in any missing information.

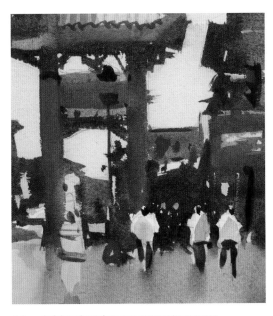

A few deft brushstrokes can suggest a person, place, or thing.

Summing Up

This approach to line prompts us to develop a more selective eye. Lines can add structure to a subject and lead us through it. We look for the key features of a subject and then use lines to express them. Lines make symbols, which are a form of visual shorthand. Our impressions of objects are represented through the action of a brush and paint, but this is not all technique. We are interpreters, translating our ideas about a subject as we paint.

Chapter 6

CONVEYING DYNAMIC
TEXTURES

In watercolor, texture is largely an illusion. No daubs of paint protrude from the surface of our paintings. The pigment makes sheer films of color. The only physical texture in watercolor—the one we can actually feel—is the surface of our paper.

This is in no way a limitation. We can use texture creatively. The physical properties of our pigments influence the appearance of a wash. The choice of paper and technique affects the edges of our brushstrokes, as does our method of delivering paint. We can use textures to indicate how things might feel to the touch or selectively make areas more entertaining. Textures make shapes more interesting.

Best of all, incorporating textures in our watercolors encourages us to focus on the interaction of our materials. As we learn to apply textures, we become better painters.

All this is done in the same way we create lines and shapes: by orchestrating what our viewers see.

Leslie Frontz, *Lands End Farm*, detail, watercolor on paper. Granulating pigment have a mottled appearance, clearly visible in the farmhouse and sky.

Textural Properties of Pigments

We easily see that each pigment has a textural quality. Some have a grainy appearance on the paper; others are clear and transparent. A few have a slightly denser appearance. The texture of our paper influences how visible these effects will be.

Granulating Pigments

Pigments like burnt umber or ultramarine blue—the first an earth color, the second a mineral—deposit sediment as they settle into the paper. They look speckled, a quality that suggests texture.

Staining Pigments

Phthalo blue is an example of a staining pigment. It leaves behind a visible trace when we try to lift this color from our paper. This technique creates interesting variations within a line or shape.

Gently sponging a staining pigment removes some, but not all, of the paint. Used with stencils, this technique suggests many textural effects. The results are limited only by our imagination. Handmade stencils can be quickly fashioned by tearing or cutting index cards.

Opaque Pigments

Some pigments, like those made from cadmium, are *relatively* more opaque. When applied in strength, they have a slightly denser appearance. This does not make them unsuitable for watercolor. All pigments make sheer, transparent films of color when mixed with water.

Opaque pigments are often vibrant colors. They hold their position more firmly on damp paper. This characteristic makes it possible to create shapes with soft but relatively precise edges.

Cadmium red and cobalt turquoise, both described as opaque pigments, disperse more slowly on wet paper than transparent pigments.

Stencils yield interesting results when used with staining pigments such as phthalo blue.

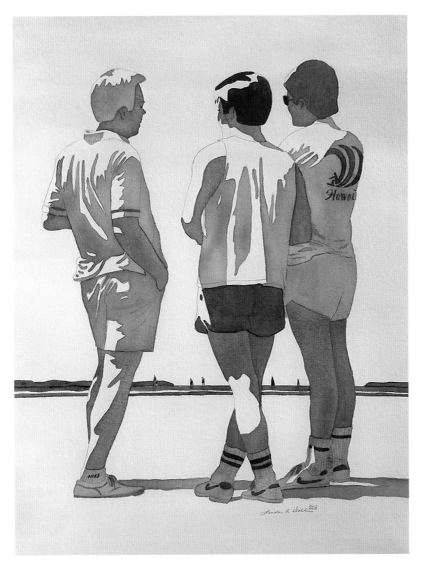

Linda Doll, *Son-Rapt*, 24" × 18",
watercolor on paper.
The artist enhances her subjects
with a smooth texture, applying the
paint in even, fluid films of color.

Paper Surfaces

The different surfaces of watercolor paper—hot-press, cold-press, and
rough—extend the range of textural effects available to watercolor artists.
A brush glides easily across smooth papers. Rougher papers are more
likely to produce brushstrokes with broken edges. The surface of our paper
deserves consideration. It plays an important role in determining what
happens when we apply paint.

Wet pigment tends to puddle on the smooth surface of hot-pressed paper. Even when dry, the paint looks liquid.

Hot-Pressed Paper

Hot-pressed paper has no hills and valleys. A brush moves freely across its surface, creating smooth strokes of color. This paper has a hard, flat surface, encouraging wet paint to pool up more easily. Backruns are a more common occurrence on this smooth paper. The resulting blossoms suggest textures, but the technique requires both practice and good timing.

Rough Paper

Rough paper produces rough brushstrokes. The pronounced texture of this paper prevents a brush from depositing pigment in the low spots, creating a speckled, glittering effect. Lines and shapes are more likely to have broken edges. It takes more pressure on the brush to apply paint evenly on a textured surface. Smooth brushstrokes are more easily made with watery pigment.

The texture of a brushstroke is influenced by the paper's surface. On the top is smooth paper. On the bottom is rough.

Cold-Pressed Paper

Cold-pressed paper provides a compromise between smooth and rough surfaces. It has an obliging, slightly toothy texture. This surface produces varied brushstrokes: smooth, broken, and coarse. Backruns are less likely to occur on this paper, a factor to consider when "blooms" are the desired outcome.

The "best" paper depends on what we want our brushes and pigments to do. Choosing the right painting surface ensures that we can produce the results we want.

Pigment "blooms" can be used to suggest textures, but they are also unpredictable.

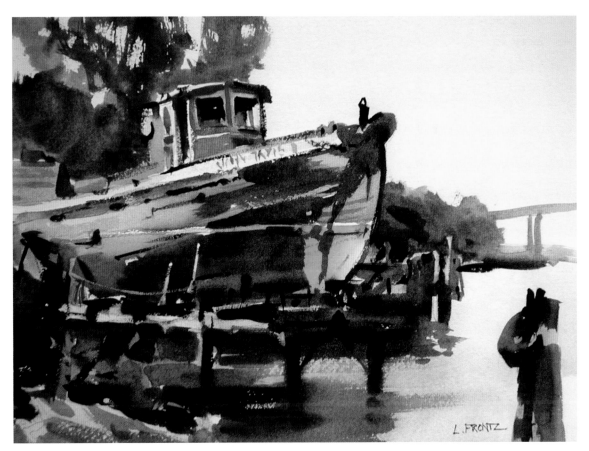

Leslie Frontz, *Carolina Tug*, 8½" × 11½", watercolor on paper.
Cold-pressed paper has moderate hills and valleys on its surface. Its subtle texture accommodates a range of marks from smooth to rough.

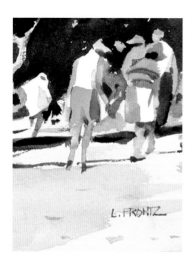

Creating Textural Edges

Our materials allow us to create expressive textures. Smooth contours are a good match for glossy objects. Soft edges are a good match for a velvety surface or a shadowy edge. Rough brushstrokes suggest the character of worn surfaces. The textures we wish to capture influence our choice of materials and methods.

A smooth brushstroke requires only fluid pigment and firm, even pressure on the brush. A subject requiring broken edges on anything but rough paper requires some finesse. We use less pressure, change the angle of the brush, and move the brush more quickly. A light touch deposits paint on the high spots; so does holding the brush horizontally. Painting more rapidly prevents us from depositing too much pigment in one spot.

Leslie Frontz, *Freckles*, detail, watercolor on paper.
To describe textures in watercolor, we can suggest how things feel. Smooth contours and soft interior edges suggest the smooth fur on a soft dog.

A broken edge occurs when pigment touches only the high spots on a textured paper.

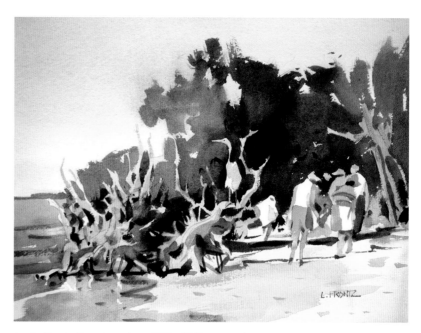

Holding the brush in an upright position pushes paint into the valleys of the paper. This technique produces smoother edges.

Leslie Frontz, *Beachcombers*, 8½" × 11½", watercolor on paper.
Broken edges are easier to paint on a textured paper, but the way we move a brush also affects their appearance.

Leslie Frontz, *Paddington Station*, detail, watercolor on paper.
The contour around the figure has a varied texture. Some portions are smooth or rough. In other areas, the edge dissolves.

Finding and Losing Edges

Lost-and-found is a term used to describe edges with deliberately varied qualities. A single contour changes from obvious to obscure, from a defined edge to a soft one. An edge is "lost" where it is diffuse and "found" where it becomes sharp and distinct.

This technique has long been associated with watercolor, although it is put to good use in all forms of painting. The human eye focuses on one point at a time; everything else is less distinct. This makes lost-and-found edges both familiar and satisfying. They are also quite useful, encouraging our viewers to pause, linger, or move on to a more interesting spot.

David Poxon, *In a Farmyard*,
18" × 26", watercolor on paper.
In capturing this subject's
shapes and colors, the artist
convincingly portrays the
beauty of its surface.

Conveying Physical Textures

Introducing texture to a watercolor painting is a process; it most often occurs throughout the development of a painting. To create the illusion of textures, we contrast values and colors and create layers of shapes and lines.

This basic approach allow us to faithfully mimic the surface of an object. Small spots of paint appear to be rusty metal or rough pavement. A network of fine lines can duplicate the appearance of crackled paint, coarse fibers, or a host of other surface textures.

We can also more broadly interpret textures. Qualities such as hard and soft, firm and pliable—textures that have no consistent visual appearance—can also be captured in watercolor.

Some expertise with a brush, the thoughtful manipulation of water and color, and a creative approach to the use of varied materials and techniques are all that is required to master texture in watercolor. These are the same skills that we have been developing throughout this course.

Reference Photo: The weathered wood in this subject appears rough in places and smooth in others. The interaction between brush and paper persuades us that a watercolor has these same textures.

DEMONSTRATION: Washed Ashore

The first wash is blocked in on wet paper. The softer qualities of the water and beach are represented by gentle transitions of color.

STAGE 1

Both water and sand have soft, yielding surfaces. The beach is grainy, the water transparent.

A wet-into-wet wash provides soft edges. Earth colors have a grainy quality, while phthalo green is very transparent. The strokes made by a large round brush are a good match for this varied subject.

- The water is pale phthalo green. Areas of clear water suggest gentle waves.

- Raw sienna is brushed over the beach. Burnt umber and Indian red create darker patches, suggesting high and low spots in the sand.

- The tree trunks are also painted with clear water; the surrounding pigment is allowed to flow into these areas.

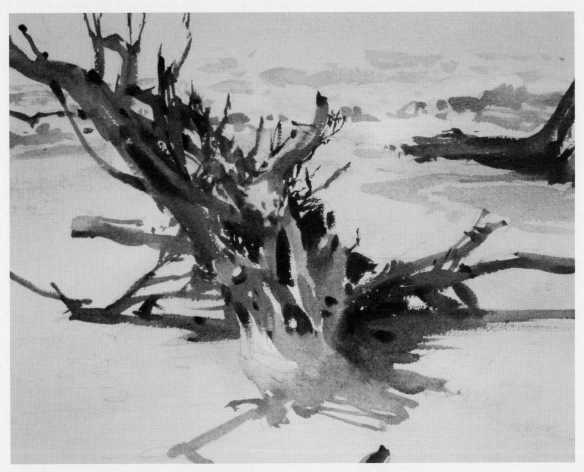

The texture of the weathered wood is defined with changes in color and value, some lines, and a variety of textured edges.

STAGE 2

When the wash is dry, another layer of pigment develops the surfaces. The lapping waves, shadows, and wet spots on the sand are smooth shapes. The polished and rough areas of the trunks are defined by their edges.

Round brushes suit the shapes and edges in the subject.

- Varied greens suggest small waves breaking on the shore.

- Wet-against-wet strokes are applied to the large trunk, imitating its smooth surface. The distant trunk is painted in the same manner.

- Recesses in the trunks are suggested with dark pigment. Cast shadows and patches of wet sand are added to the beach.

- Small, rough strokes suggest the coarse roots on the large stump.

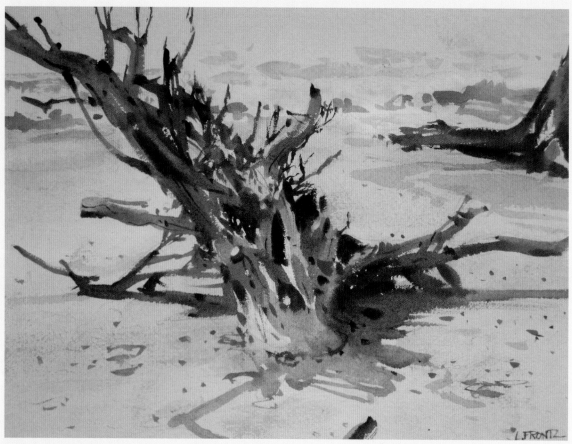

Lines and spots add texture to the large trunk and develop the foreground.

STAGE 3

In this last stage, the beach receives more attention. Small shapes and lines suggest the pieces of bark and shell that add texture to the beach.

Adding more calligraphy brings the large trunk into focus.

In this version, medium and small round brushes see the most use.

- At the base of the large trunk, strokes of pale raw sienna are rough-brushed across the paper.

- Delicate lines indicate the wood grain of this trunk. More spots give its surface a pitted appearance.

- A variety of marks suggest the texture of the foreground, giving the scene greater depth.

Using Texture to Improve a Subject

Not all subjects present textures that are visible to the eye. The material that makes a pillow soft is hidden from view. When seen from a distance, the details of objects are seldom visible, yet we remain aware of their textures. Watercolor allows us to convey these qualities without copying the appearance of physical textures.

In watercolor painting, we can suggest the texture of a subject as we describe other aspects of its appearance. This demonstration reveals how to use texture to capture these more elusive qualities. While we may often be inclined to copy what we see, seeking out ways to improve a subject often requires us to paint what we do not see.

Reference Photos: Both photos have more and less promising features. Above is a scenic view with hard, rocky mesas. The one below draws attention to the softer trees and sky. Together they make a compelling subject.

DEMONSTRATION: Mesa Country

This subject was chosen for its textures: dense clouds,
a hard ridge, and dry range.

STAGE 1

Textures can be used to improve a subject: to
interpret its spirit more than its appearance. In this
stage, granulating pigments suggest the weight of
rain-filled clouds.

A large brush makes quick work of this wash on dry
paper, which features many color changes.

- A pale yellow wash is distributed over the sky,
 suggesting light filtering through the clouds.
 All highlights are unpainted paper.

- Phthalo blue—as clear and transparent as the
 sky—is introduced along the tops of the mesas.

- Using ultramarine blue and Indian red, both
 sedimentary pigments, gives the clouds a
 denser look.

When the sky wash is dry, hard edges define the mesas.
This stage establishes the masses and hints at their textures.

STAGE 2

Hard edges define the ridge; soft edges suggest lacy foliage. The pigments used for the mesas and trees reflect the subject's visual qualities.

A wet-against-wet wash allows for both hard and soft edges. Medium and large brushes are used in this stage.

- Indian red, burnt umber, and ultramarine blue add a slight grain to the cliffs. Their sunlit sides are left unpainted.

- Mixes of opaque pigments—cadmium yellow or lemon with cobalt turquoise—give the foliage substance, bringing it forward in space.

- A mix of raw sienna and cadmium yellow covers the range; a strip of white paper makes a path.

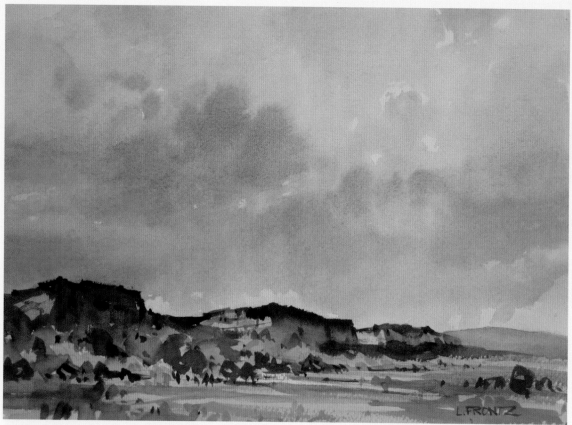

Smaller strokes of color give the textures more definition and explain the subject more specifically.

STAGE 3

This is a quiet subject, and textures create an active surface. Suggesting rather than imitating textures is an appropriate choice. The amount of detail is kept to a minimum.

Large or medium brushes will see the most use in this stage.

- Mixes of dull orange are glazed over the sunlit sides of the mesas.

- Dark, shrubby shapes are added among the nearest trees.

- Drier pigment is dragged across the paper in broad strokes, suggesting the dry range.

- A few delicate lines suggest fissures in the sunlit rocks. Brushstrokes hint at grasses and small shrubs in the foreground.

Leslie Frontz, *Rocky Shore*,
9" × 14", watercolor on paper.
Pigment has been stamped,
sponged, and scraped across
the paper to obtain a greater
variety of textural effects.

Creating Textures with Special Effects

As watercolorists, we may have an unfair advantage when it comes to texture.
The fluid nature of the paint encourages us to make gestural brushstrokes.
A brush is only the beginning. Many objects leave marks on paper. From this
perspective, we have access to an unlimited supply of painting tools. What
matters is what works for us.

When using special effects, timing is often critical, and the results can be
unpredictable. There are many techniques, but most fall into a few categories.

SPATTERING AND SPRAYING

Random droplets of paint or water can be spattered or flicked onto dry or
moist passages of paint. Artists flick paint from brushes and toothbrushes.
Misters dispense sprays of pigment.

The shape of the small flecks of paint will vary with the tools used, as will the
pattern of spray. Shaking paint from a large, round brush will drop splotches of
paint on the paper. Flicking pigment from a toothbrush makes a fine pattern of
pigment. Flung paint typically has a directional emphasis; the droplets tend to
fall in a perceptible line. By substituting clear water for paint, we can deliberately
make small backruns. White gouache leaves a light spatter on dark passages.

This is a delicate technique when used with restraint, a dynamic one when
applied with more energy. Spatter suggests the texture of many subjects that
we might describe as speckled: sand, stone, earth, and rust.

Flung and spattered drops
of pigment form gravelly,
grainy patterns of droplets on
watercolor paper.

Scraping and scoring wet or damp paint creates a variety of marks.

Stamping objects loaded with pigment adds a different kind of texture to dry or wet paper.

SCRAPING

Firmly scraping wet pigment from damp paper exposes the unpainted paper below. This technique makes linear marks that match the width of the tool used to create them. It is most useful for objects that are easily translated with lines, such as fence posts and flagpoles. A pocketknife is traditionally used for this purpose. Some flat brushes feature an angled end designed expressly for scraping paint from paper.

Timing is critical for this technique. If the paper is just damp, scraping leaves light marks, which is most often the desired effect. When the paper is still wet, the surrounding pigment will flow back into the scraped area. The damaged paper absorbs the pigment, making the lines quite dark. Finer dark lines are made by scoring damp or wet paper with a penknife. This is an easy way to suggest telephone wires, twigs, and grasses.

Used on dry paper, a penknife can scrape back delicate lines or flecks of white paper. This technique can substitute for gouache when making thin white lines in a passage of paint. The effect is more ragged than a brushstroke, but this is often an attractive quality.

STAMPING

Any object that will accept paint can be used as a stamp. Natural and synthetic sponges, pieces of cardboard, leaves, woven fabrics, crumpled paper, and netting are among the more common examples of materials used for this purpose. If the object has a directional pattern, it is important to remember that this is a print of an object. The pattern will appear in reverse when stamped on the paper. This technique is limited only by our imagination.

SPRINKLING

Salt absorbs moist pigment from the surface of a painting. As the paint is absorbed, lighter "stars" appear on the paper. The results range from pale speckles to splotches with dark centers. The size of the crystals influences the size of the blooms. With standard table salt, the crystals typically dissolve before absorbing the pigment. Sea and rock salt work well, but the amount of moisture in the paper still affects the result. After the passage dries, any remaining salt is brushed from the surface of the paper.

All these techniques easily describe the textures of objects: a dry leaf, a pitted wall, or a grassy slope. They may also stand in for objects: snowflakes, boat rigging, foliage on trees, or flowers in a field. Textures are also used simply to add interest to a passage of paint.

Adding textures to objects invites speculation about them. A peeling wall has been left unattended. A patched stucco wall suggests its age and location. Textures suggest more than appearances; they evoke character as well. Like all elements we have explored, textures help us to organize the surface of our watercolors and capture the nature of our subjects.

Salt crystals pulls up damp pigment, leaving behind a starry pattern.

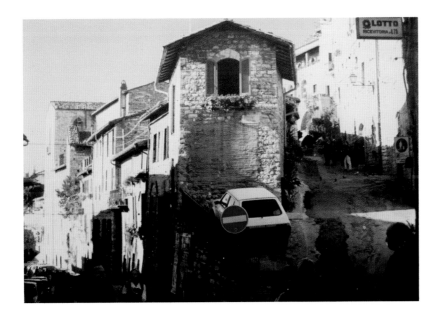

Reference Photo: Subjects that feature textures offer a good starting point when exploring special effects. This view includes stone, tile, and pavement, all showing age.

DEMONSTRATION: One for the Ages

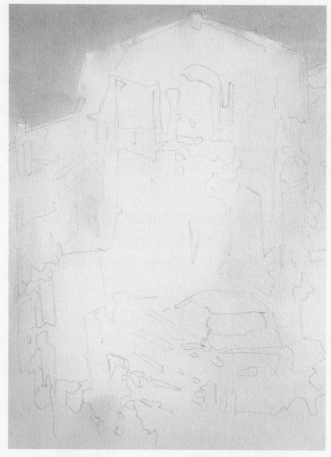

A simple foundation provides a good starting point for the textural marks that follow.

STAGE 1

This first wash creates two massed shapes that share a defined edge: a village and a sky.

Using large brushes makes it easy to paint this stage. In this version of the wash, the walls are varied in color, and the sky is uniform.

- The sky is painted pale phthalo blue. A narrow strip of dry paper just above the roofline is left unpainted.

- The walls below the roof are pale mixes of raw sienna, burnt umber, and Indian red, again chosen for their grainy texture.

- Touching water to a few areas along the roof allows a small amount of color to flow between the two shapes.

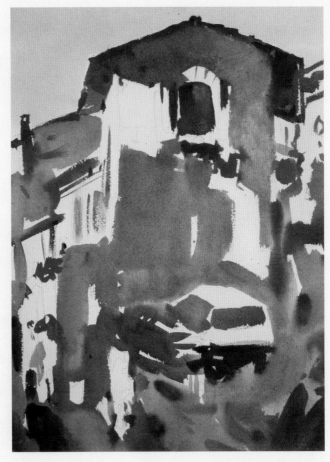

Regardless of technique, shapes receive the same studied attention.

STAGE 2

A wet-against-wet wash painted on dry paper creates an area for experimenting with special effects. Granulating pigments are used extensively.

A pocketknife, cotton swab, natural sponge, cardboard, salt, matchsticks, and brushes are used to create textural marks on paper.

- The eaves and window are mixes of burnt umber, Indian red, and ultramarine blue. Below the window, raw sienna and dull purples are added to the wash. Small green strokes suggest foliage.

- Lines are scraped under the eaves with a pocketknife. Water, pigment, and salt are spattered or sprinkled into the damp paint. Lines are brushed, stamped, and dragged onto the paper.

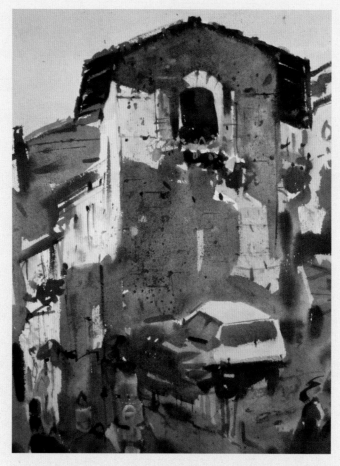

Special effects transform the masses into an Italian village.

STAGE 3

The application of special effects begins while the pigment is still wet. How they are used depends on personal choice, and guidelines are offered instead of instructions.

- A brush is used to layer paint on surfaces, add lines of gouache, and wash color over unpainted shapes.

- In wet paint, broad lines are scraped and salt "stars" are created.

- Pigment is spattered onto surfaces and stamped with a natural sponge or cotton swab.

- Irregular marks are made by dragging paint across the paper with cardboard or matchsticks.

Summing Up

Textures bring a subject to life. With a considered choice of brushes, pigments, and other painting tools, we can learn how to mimic or imply the surface of objects. This is a skill worth learning; textures appeal to our sense of touch. They express the visual character of a subject, directing our attention to what are most often their most telling features.

Liese Sadler, *Landscape Textures*, 9" × 6", watercolor on paper. This watercolorist is also a fiber artist, and her interest in surfaces clearly shows in this painting. The rows of textured brushstrokes loosely indicate landscape forms.

Chapter 7

EXPRESSING THE
MOOD
OF A SUBJECT

W e choose a subject because it holds our interest. Its appearance may be the first thing we note, but something more prompts us to paint it. In one way or another, a subject captures our imagination.

A subject is ultimately more than a set of objects or a collection of shapes. We may respond to the light that illuminates it. The time of day and season of the year may also affect our perception. We may hold a cherished memory of a place or object. Many intangible qualities contribute to our impression of a subject.

However this comes about, our subject moves us to make a record of the sum total of it: the *experience* that prompted our interest. We associate our subject with an idea or mood. We might think of this response as an undercurrent in a stream: lying below the surface, but guiding our thoughts in one direction. Our intention is to invite the viewer to experience this same moment of discovery.

Leslie Frontz, *Chandler's Wharf*, 8 ½" × 11 ½", watercolor on paper.
This watercolor represents a leisurely morning stroll. The bright sunlight and company of friends and family made the event memorable.

Ray Balkwill, *Evening Sail, Exe Estuary*, 10" × 8", mixed media on paper.
We share the artist's pleasure in a quiet moment overlooking a peaceful estuary.

Considering a Subject

Often a subject appears so effortlessly that it seems to choose us. It may be a floppy-brimmed hat shielding a child from the sun. The next time, a pattern of tropical shadows or traffic on a city street. There is nothing especially noteworthy about a hat, a shadow, or traffic. We have made an association, finding something significant in what we see.

Often our explanation for choosing a subject is simply that we "like" it. If prompted, we might identify an item that caught our eye. We know only that it captured our attention.

A better strategy is to focus on the character of a subject. An "old dog lying in a sunny spot" suggests a mood. We can express this attitude in paint. If we think about the same subject simply as a list of objects—a dog, a door, and floorboards—the mood is lost.

Capturing Weather and Light

Capturing a subject typically involves more than conveying its physical appearance: it is our unique response that makes it worth painting. Exploring weather and light provides an easy way to investigate this idea; both are familiar features of everything we see. We have an intuitive grasp of how weather and light affect our own mood and can put this information to good use in our paintings. Our skills improve as we begin to view the world with an artist's eye.

Ted Vander Roest, *Pembrook Street*, **10½" × 14", watercolor on paper.**
This everyday scene has a still, secluded air. The artist often paints subjects that seem both ordinary and mysterious.

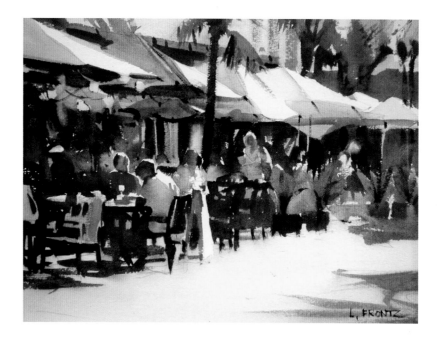

Leslie Frontz, *Lunch Bunch*, **8½" × 11½", watercolor on paper.**
The appeal of this watercolor is largely due to the effect of sunlight. A duller day would be less inviting.

Observing Weather and Light

Interpreting weather in watercolor is much easier than we might think. The stumbling block is usually our lack of information. While we are constantly looking at the world around us, we tend not to see it in a useful way.

On a clear day, the sky overhead will likely be a deep blue. This is the color that we associate with a sunny sky, and we use it accordingly. We ignore the fact that we only see this color when looking directly overhead.

The color of the sky changes dramatically as we look out at the surrounding landscape. Below the zenith, the same sky becomes a lighter blue, followed by a greener blue. A subtle blush of red is visible just above the horizon.

To translate weather and light, we use colors and values to capture a scene. A sunlit surface must look right in relation to its shadow. The colors we see are affected by weather and time of day. When something in our painting looks out of place, we check to see if it is too light or dark, too bright or dull, or the wrong hue.

The same basic principles apply when painting a still life, portrait, or interior. As artists, we are much like stage managers. Our intent is to set the mood.

Studying Outdoor and Indoor Moods

We choose how to present our subject, interpreting rather than copying what we see. We may dim or exaggerate light or even change the weather. Altering the source, direction, or quality of light might improve it. To learn how to make these changes, we turn to nature.

Many light effects are fleeting, so it makes sense to cultivate our memory with on-the-spot studies. We know that photos are seldom truthful. We overcome this obstacle by making our own observations.

Sketching outdoors in watercolor is an enjoyable way to learn how to evoke the many moods associated with weather and light. This does not have to involve any ambitious projects. A study may focus on shadows cast by trees, a dramatic sky, or a patch of sunlight in a bed of moss. This information can be gathered quickly in any quiet corner. The goal is not to make a finished painting—although certainly this is a worthy undertaking—but to understand how weather and light affect the appearance of a subject.

On busy days, taking a few moments to look out the window will add to our store of information. As weather and light change, so does the mood.

Leslie Frontz, *Outdoor Sketches***, watercolor on paper.**
These studies record only the essentials. They provide useful information when tackling similar subjects in the studio.

Leslie Frontz, *All Aboard* **(detail), watercolor on paper.**
Even the flat light of the midday sun has its charm. Here it suggests a slow, unhurried moment as passengers wait to board their train.

This is a gray day for a trip to the shore. The light was perfect just before this photo was snapped. The sun was pleasantly warm, and everyone was in a buoyant mood.

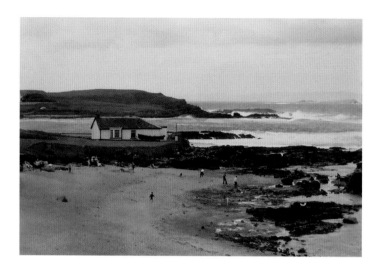

Leslie Frontz, *Antrim Coast*, 11" × 14", watercolor on paper.
Changing the colors and values transformed the mood from dreary to cheery.

Transforming a Mood

Weather is not always cooperative. We might ponder why the figures in the photograph (left) have gathered at the beach on this dull day. The view is spectacular, but its mood is not welcoming. We can change the weather—and the mood—by manipulating the colors and values. The process is simple and logical once we think it through.

Altering the colors and values brings out the sun. In the watercolor, the sky and sea are no longer gray. The planes facing the sun—the beach, grass, breakers, and the side of the building—are receiving more light. The colors are warmer, and the value contrasts are stronger. These changes are not extreme, but the difference in mood is dramatic. The beachcombers are clearly enjoying their trip to the shore.

Conveying Mood in Watercolor

It often takes only a moment to decide that a subject would make an appealing watercolor. That moment is important. A lot happens between seeing a subject and choosing to paint it. We no longer see objects. We see a subject with potential. Thoughts, memories, and moods have intervened.

To understand how mood is captured with paint, it is helpful to have input from more than one artist. We all make different connections with a subject. Each of us approaches the expression of mood in a unique way. With this in mind, the demonstrations in this chapter feature the work of three artists.

Bill Vrscak, *Etna Winter*,
18" × 24", watercolor on paper.
The colors in this watercolor
are soft and hushed. We can
imagine the frosty air and feel
the quiet stillness of winter
gathering around us.

Jim McFarlane, *The Reference Photo*, *Jamaican Holiday*, digital photograph.
The sleepy roadside shops in Jamaica are handmade; each is unique and most are colorful.

Jim McFarlane, *Figure Reference*, digital photograph.
This is a snapshot of a figure from another area on the island. McFarlane often takes photos of people and things that he might use to enhance other subjects.

FEATURED ARTIST: JIM MCFARLANE

Conveying a Tropical Mood

Artist Jim McFarlane has a real affection for these quirky Jamaican "stores." He finds inspiration in the slow rhythm of the island as well as the visual qualities of the setting. A sunny road is bordered by deep shadows, and a vibrant blue sky beckons through tropical foliage. In this demonstration, the artist masterfully captures the mood and atmosphere of this exotic location.

The pattern of lights and darks in the photograph creates a bold dividing line between sunshine and shadow. The upper left corner is dark; the lower right is light. This shift in values will create a sunny, cheerful mood. The edge that separates sun from shade moves diagonally upward at the right, but much of its length is flat and featureless.

The inspired addition of a figure and sign makes a livelier pattern. As McFarlane redirects the edge, it takes on a more appealing rhythm. The line still travels diagonally from the lower left to the upper right, but its new path has a stronger character.

Jim McFarlane, *The Line Drawing*, digital photograph.
In the drawing, the artist adjusts his subject to make the shapes and lines more dynamic.

DEMONSTRATION: Jamaican Holiday

Jim McFarlane, *Blocking In the Pattern*, **digital photograph.**
McFarlane advocates previewing the values directly on the
watercolor paper. White paper represents the lightest values.
Pale values stand in for the midtones and darks. In this stage,
he is trying to capture only the value relationships.

STAGE 1

A light wash is used to produce a faint preview of
the value pattern. White paper represents the light
values. Diluted and concentrated mixes of raw
sienna stand in for midtones and darks.

The transitions among the values are soft and loose,
allowing McFarlane more freedom to revise the
edges of shapes.

- Raw sienna creates a sunny mood for this subject.
 Its warmth makes it a natural choice.

- The artist paints around negative shapes,
 although masking fluid can be used instead.

- Varied tones of raw sienna identify where
 changes in value will occur. This wash captures
 only the general value pattern.

- McFarlane completes the wash by adjusting
 values and edges that seem out of place.

Jim McFarlane, *Adding Color,* **digital photograph.**
In this stage, McFarlane lets loose with light, flowing washes and rich darks. He paints shapes, not things, summarizing their relationships instead of duplicating what he sees.

STAGE 2

This stage is critical; it creates the large masses. Their qualities set the mood. Two shapes, one warm and one light, meet along a line that moves diagonally across the paper.

The artist lets the pigments choose their own course, allowing them to mingle and run. McFarlane does not corral them between the lines.

- Pale, warm colors are allowed to flow through the sunny areas. Light blues indicate the sky.

- Layered washes of dark green suggest the dense canopy of leaves. Changing color distinguishes leaves from trees.

- Lighter elements like the figure and shop are defined by the surrounding darks. Muted midtones are added to objects in the foreground.

Jim McFarlane *Jamaican Holiday*, 15" × 22", watercolor on paper. McFarlane adds layers of paint and linear brushstrokes to suggest different textures in the foreground shapes: sign, fence, road, barrel, path, figure, storefront, and sun-washed foliage.

STAGE 3

To complete the painting, McFarlane develops the brighter, lighter passages. He pays close attention to their relationships: brighter and duller, cooler and warmer, lighter and darker.

The artist measures success as capturing the qualities that attracted him to a subject: the sunlight and bright colors of the tropics.

- The figure, shop, and barrels are described with bright colors. Lines and shadows emphasize these foreground objects.

- Layers of color add dimension and texture throughout.

- Spots of pigment are lifted from the tree trunks, suggesting light filtering through the leaves.

- The intervals between leaves are made a darker, brighter blue, suggesting a perfect holiday.

NYC, digital photograph.
Isolating areas within a scene makes it easier to see how they differ. This excerpt eliminates the lofty verticals and can be described simply: more shapes and a more active feeling.

FEATURED ARTIST: PAUL TOOLEY

Interpreting the Rhythm of City Life

A bustling city street is far removed from the sleepy back roads in Jamaica. Both feature a simple background: a collection of trees or buildings seen against the sky. Both have a prominent horizontal ground plane: a dusty road or urban street. What each artist interprets—the mood and atmosphere— is quite different.

Artist Paul Tooley finds a special appeal in the activities of people in urban settings. They may be exploring an outdoor market, skating at Rockefeller Center, or making their way along a rain-slick road. The reference photograph captures a specific time and place. Tooley uses it as inspiration for a watercolor that conveys the energy and motion of city life.

Tooley begins by drawing his subject on the paper with fluid paint, weighing the best weight and color for each line before putting brush to paper, and then adds a generous dose of shapes in primary and secondary colors to complete his watercolor.

Paul Tooley, *The Reference Photo*, *NYC*, digital photograph.

DEMONSTRATION: NYC

Paul Tooley, *Establishing Shapes Using Loose Line Work*, digital photograph.
The artist starts his watercolor by exploring his subject with calligraphy.

STAGE 1

Tooley's approach includes drawing the subject on the paper with paint, establishing the key contours of his subject with fluid, colorful lines.

The artist is interested in revealing the liquid nature of watercolor as well as capturing the spirit of his subject.

- Warm and cool lines capture the towering skyscrapers.

- Lower on the page, the warm lines indicate brightly colored signs and billboards.

- Flowing lines stand in for people navigating the busy street. Bold lines indicate the heavy traffic.

Paul Tooley, *Blocking in Values and Color*, digital photograph
Using a big brush and fluid pigment, Tooley places shape against shape
and color against color. The pattern that emerges suggests both visual
and expressive qualities of the subject.

STAGE 2

Broader shapes are introduced, further defining
the architecture. The colors reflect observable
differences between light and dark, warm and cool.

The liquid passages are encouraged to flow and
pool, allowing the pigments to mingle and merge on
the paper.

- Loose washes of pale and muted colors are
 distributed on the buildings on the left.

- Red spots are added to signs below and repeated
 in the sky.

- Vibrant blues and purples define figures and
 architectural elements. Small yellow notes are
 added at the bottom right.

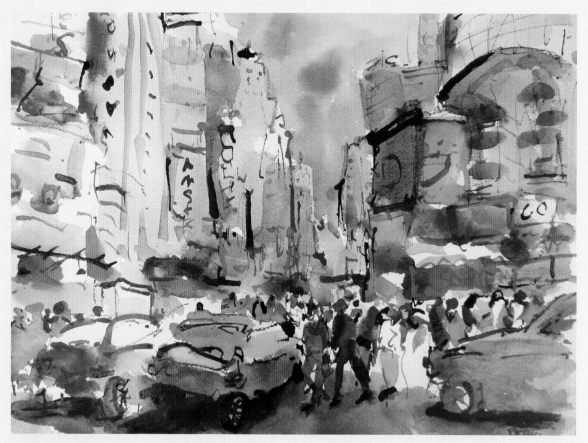

Paul Tooley, *NYC*, 11" × 15", watercolor on paper.
The active lines and vibrant colors successfully capture the
energy of a busy city street.

STAGE 3

Layering lines and washes over dry paint captures
this specific scene. A studied look reveals that the
artist has observed his subject closely.

This interpretation captures not only the appearance
of the subject, but also its mood. The pace and
energy of city life is evident in every brushstroke.

- Lines and spots add more signs and identify
 individual buildings.

- Windows are suggested by repeating small
 strokes of color.

- Warm and cool pigments give form to the
 vehicles. The darker values in this area suggest
 the more filtered light.

- Circles and splotches suggest a crowd.

Stacey Hunt, *Untitled*, **digital photograph.**
Reference Photo: The colors and values in this photograph will easily convey the mood of a day at the beach.

Capturing the Moment

This appealing image provides all the information needed to make a sensitive portrait. Using a child as a subject makes the translation of a mood a simpler task. At this age, the response to our surroundings is focused and compelling. Our viewers can experience the world from a toddler's perspective: lapping water, warm sand, and sea air come to mind.

DEMONSTRATION: Fun in the Sun

The rippling water and sandy beach explain the light and atmosphere. Together they form a background that plays up the silhouette of the child and toys.

STAGE 1

The first wash translates the warm and cool colors in the waves. The sunlit side is picking up sand, and the cool side is reflecting the sky. Warmer, more muted colors suggest a beach.

A wash on dry paper lets us reserve white paper for other colors. A large brush is used for this wash.

- A band of raw sienna extends from the left to the hat and chair. It continues on the right side of the paper.

- More bands of raw sienna are applied below the first. Stripes of pale ultramarine are added between them.

- The chair is painted with ultramarine and quinacridone rose.

- The beach is a wash of raw sienna, cadmium red, and Indian red.

This subject makes use of every primary in the double triad palette. The rich, vibrant colors set an appropriate mood.

STAGE 2

This subject features more nuances of color. A red may be more pink, purple, orange, or brown. Many passages remain white paper.

Using the wet-against-wet technique will soften the edges between color changes. A large round is used for this stage.

- Red and orange hues are used for the child's face, hat, shirt, arms, legs, and sand pail.

- The brim of the hat, sunglasses, and other blue spots are added to the figure.

- The toys are painted using all six primaries, avoiding areas that will be painted with the lightest pigments.

- The shorts are yellow; the shadows cast by the chair are dull purple.

The finished painting suggests that much effort is required to complete this stage, but there is really not much left to do.

STAGE 3

Color is added to the white passages. Smaller spots and lines bring the subject into focus.

When the watercolor begins to look like the subject, it is time to consider what else needs to be said. We are attempting to suggest something more than the appearance of this scene.

- When the watercolor is completely dry, color is added to all unpainted shapes. The bright hues contribute to the mood.

- The child's mouth is added; it is just a small shape. The nose and chin are suggested by lifting paint with a damp brush and blotting the area with a tissue.

- Touches of pigment and gouache complete the subject.

Summing Up

To capture a subject, we often want to express something more than the way it looks. Exploring weather and light provides an easy way to begin investigating this idea. Both are familiar to us, providing a common ground for sharing our response to a subject. We have an intuitive grasp of how weather and light affect us and can put this information to good use when painting.

This is just the beginning; every stroke of paint has a potential for expression. The choice is ours. We choose shapes, create patterns of values and colors, make pathways with lines, and suggest textures that appeal to our sense of touch. We can share the way we experience a subject as well as what we see.

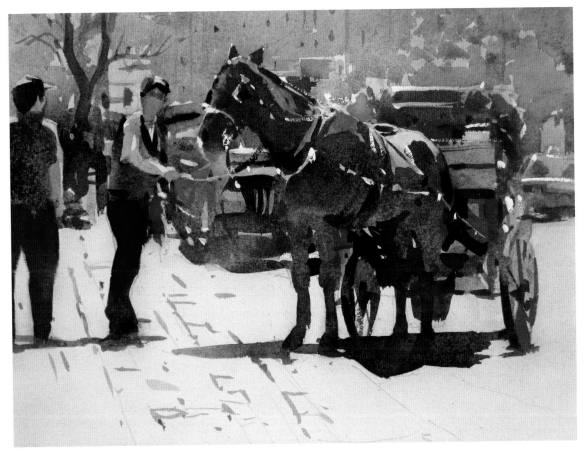

Leslie Frontz, *Patience*, 11" × 15", watercolor on paper.
The colors in this scene were inspired more by the mood than the appearance of the scene: a spring day in Central Park.

CONCLUSION

Looking at the watercolors of artists we admire, it is clear that their work has a distinctive look and feel. Although it seems logical that by following in their footsteps we would quickly find our own path, this tactic seldom allows us to evolve our own style. We can see what they do, but what we personally want to achieve remains elusive.

The lessons in this book can help you develop your own personal style. It is the choices we make about painting our subjects that lay the foundation of style. Decisions about using shapes, value contrasts, and color combinations give our work its individuality. So does our approach to applying and using lines and textures.

One artist may create elegant shapes that glide majestically across the paper. Another may favor a jazzy jumble of bright colors. These are evidence of deliberate selections made with a focused intent. This brings us full circle. As we continue to paint watercolors, our preferences blend seamlessly to produce what we call style.

Both watercolors feature boats on the water. Different choices give each of these subjects a different look.

Leslie Frontz, *Sailboats on Cape Fear*, 8½" × 11½", watercolor on paper.

Leslie Frontz, *Derelict*, 10" × 15", watercolor on paper.

Our journey begins and ends by considering how artists interpret a subject. We look at our inspiration with an artist's eye, translating it as shapes on paper. Our range of options is extensive, from juicy darks to films of glowing color. We marvel at the fluid trails and spatters of transparent pigment.

Watercolor is a versatile medium that encourages experimentation, and this book is intended to accompany the reader for the duration. Our goals and interests change with exposure to new materials and methods. Over time, the mastery of basic techniques allows us to investigate the expressive qualities of the medium. As our skills develop, the text of this book will take on more meaning, and revisiting the demonstrations on our own terms will provide opportunities to develop, evaluate, and celebrate our progress.

Watercolor is luminous and responsive, well suited for everything from portraying a fleeting inspiration to capturing the intricacies of a portrait. It is a simple, direct medium with unlimited potential, offering a lifetime of enjoyment. My final piece of advice is the same as my first: happy painting!

Leslie Frontz, *Vincenza*,
8½" × 11", watercolor on paper.

About the Author

Leslie Frontz is an experienced watercolor teacher with an impressive record of exhibitions and awards. She earned an M.F.A. degree in studio art from the University of North Carolina at Greensboro and was among the first Holderness Fellows to graduate at that institution. Her work has appeared in numerous publications.

The artist enjoys teaching and has always balanced her work as a studio artist with classes and workshops. She has shared her enthusiasm for art as an instructor at several colleges as well as a local elementary school. Her students have ranged in age from five to seventy-five, and she has enjoyed working with them all. Frontz currently conducts workshops across the country.

Frontz's interest in painting began when her parents purchased an original watercolor. The luminous color against the white paper immediately captured her imagination. As an adult, she enrolled in a watercolor workshop at the first opportunity and since then has studied with a number of notable watercolorists, including Edgar Whitney.

Frontz is a signature member of the American Watercolor Society and has received several awards from this illustrious group. She is also a signature member of the National Watercolor Society, the Southern Watercolor Society, and the Society of Women Artists in England.

Acknowledgments

To my students, whose inspiring work and discerning questions prompted me to write this book.

Special thanks go to the unsung heroines who provided advice that made the text both presentable and articulate.

Thanks go to all my fellow artists who enthusiastically shared watercolors for the book, along with a special thank you to Jim McFarlane and Paul Tooley, who so kindly provided demonstrations. Tom Hoffmann deserves special mention as the artist and author who inspired me to try my hand at writing.

Accolades also go to my editor, Kelly Snowden, who greeted this book project with enthusiasm and keen insight.

Not to be forgotten is our beagle, Freckles, who never ignored a request for companionship.

I am especially grateful to my husband, Harold, for whom no task assigned was too small or too great. This book would not have been possible without his perceptive feedback and moral support.

Index

Page 4 artwork © Winifed Breines; photograph by Stewart Clements.

Page 7 artwork © Frank Webb; photograph by Frank Webb.

Page 8 artwork © Ron Lace; photograph by Ron Lace.

Page 14 artwork © Bernard Evans; photograph by Bernard Evans.

Page 35 artwork © Sandra Carpenter; photograph by Charles Carpenter; artwork © Ross Paterson; photograph by Ross Paterson.

Page 41 artwork © Charles Reid; photograph by Donald Sigovich.

Page 47 artwork © Don Weller; photograph by Don Weller.

Page 55 artwork © Toshiko Ukon; photograph by Yasuo Imai.

Page 65 artwork © Jeff Good; photograph by Andrew Adkison; artwork © Paul Tooley; photograph by Paul Tooley.

Page 69 artwork © Tim Hacker; photograph by Tim Hacker.

Pages 70 artwork © Harold Frontz; photograph by Harold Frontz.

Page 76, 165, 166, 167, 168 artwork © Jim McFarlane; photographs by Jim McFarlane.

Page 85 artwork © Roger Parent; photograph by Roger Parent.

Page 88 artwork © Jean H. Grastorf; photograph by Zebra Color.

Page 89 artwork © Judi Betts; photograph by Lane Downs.

Page 112 artwork © Dean Mitchell; photograph by George Cott.

Page 113, 169, 170, 171, 172, artwork © Paul Tooley; photograph by Paul Tooley.

Page 118 artwork © Wilmer Anderson; photograph by Wilmer Anderson.

Page 123 artwork © Jeff Good; photograph by Andrew Adkison.

Page 130 artwork © Joyce Cavanagh-Wood; photograph by Joyce Cavanagh-Wood.

Page 135 artwork © Linda Doll; photograph by Linda Doll.

Page 140 artwork © David Poxon; photograph by David Poxon.

Page 155 artwork © Liese Sadler; photograph by Liese Sadler.

Page 158 artwork © Ray Balkwill; photograph by John Melville.

Page 159 artwork © Ted Vander Roest; photograph by Ted Vander Roest.

Page 164 artwork © Bill Vrscak; photograph by Bill Vrscak.

Page 173 photograph © Stacey Hunt.

Library of Congress Cataloging-in-Publication Data
Frontz, Leslie.
The watercolor course you've always wanted : guided lessons for beginners
and experienced artists / Leslie Frontz.—First Edition.
 pages cm
1. Watercolor painting—Technique. I. Title.
ND2420.F76 2015
751.42'2—dc23
2014048854

Trade Paperback ISBN: 978-0-77043-529-5
eBook ISBN: 978-0-77043-530-1

Printed in China

Design by Michelle Thompson | Fold & Gather Design

10 9 8 7 6 5 4 3 2 1

First Edition